MUSICIANS AS ARTISTS

MUSICIANS
AS ARTISTS

JIM McMULLAN

DICK GAUTIER

Journey Editions
Boston • Tokyo

Published in 1994 by Journey Editions
an imprint of Charles E. Tuttle Company, Inc.,
of Rutland, Vermont and Tokyo, Japan
with editorial offices at 153 Milk Street,
Boston, Massachusetts 02109

Library of Congress Cataloging-in-Publication Data
McMullan, Jim, 1936-
 Musicians as artists / by Jim McMullan & Dick Gautier.
 p. cm.
 ISBN 1-885203-06-3
 1. Musicians as artists—United States. 2. Art, Modern—20th
century—United States. 3. Musicians as artists. 4. Art,
Modern—20th century. I. Gautier, Dick. II. Title.
N6512.M375 1994
704'.78'097309045—dc20 94-29957
 CIP

Cover illustration: *The Drummer*
by Billy Dee Williams, acrylic on canvas
© 1994 Billy Dee Williams Artworks, Inc.

First Edition

ISBN 1-885203-06-3

1 3 5 7 9 10 8 6 4 2

Printed in Canada

CONTENTS

Dedicated to the memory of my loving mother Mary Madden McMullan who taught me innocence and encouraged me to express my creativity.

—Jim McMullan

Dedicated to the memory of my loving mother Marie Antoinette Gauthier.

—Dick Gautier

We gratefully acknowledge the assistance of the following:

To Quincy Jones for his perceptive and eloquent Foreword. To Peter Ackroyd, publisher of Journey Editions, who shared the vision we had for *Actors as Artists* and encouraged us in this new venture.

To our hard-working editors Kathryn Sky-Peck and Isabelle Bleecker, and to the book's designers, Paul and Carolyn Montie. To all the people at Journey Editions who supported us along the way: Roberta Scimone, Michael Kerber, Lorrie Andonian, Julie McManus, and Fran Skelly.

To everyone at the Permanent Charities Committee and especially Danielle Guttman and Lisa Paulsen, who kept the faith and helped us to finish this book.

To Jerry Sharell and Paula Jeffries at MusiCares, who gave us so much of their precious time, and to the generous people at the National Academy of Recording Arts & Sciences Foundation: Jim Berk, Dana Tomarken, Chelsea Cochrane, and especially to Mike Greene for his kind support and articulate Introduction.

To Scott Segelbaum and Marcia Williams at KLSX for their vital support in the early days.

To Stephen Stickler, our dedicated photographer, who did such a great job taking so many of the portraits in the book.

To Image Makers Art, Inc. (Colm Rowan, Mike Dutton, and John Sozanski), for all the time and energy spent on our behalf.

To Geoffrey Blumenauer, Kathy Shoemaker, Dave Spero, Peter Simon, Jill Abramson Wylly, Debbie Chesher Greenblatt, Rita Lambert, Nicholas Cowan, Mark Fenwick, Tresh Bleir, Ted Gardner, Nancy Lutzow, Lynne Naso, Brian Nelson, Nina Avramides, Lori Leve, Kaja Gula, Jennifer Ross, Alexander Sexton, Julie Glover, Susan Turner, Judy Wong Artistry, Joelle Quinn, Lee Elliot Clarke, Mack Holbert, Kevin Coogan, Leslie Oskar, and Ceil Kasha.

Jim also wishes to thank his wife Helene and sons, Sky and Tysun, for their ongoing support and encouragement. (And an extra pat on the back to Tysun, who helped sort out all the musicians and groups.)

—Dick Gautier and Jim McMullan

In memory of Michael Clarke and Jeff Porcaro

PREFACE

This book has indeed been an odd odyssey. With our first book, *Actors as Artists*, we were comfortably ensconced in our own milieu—that of the actor. We knew most of the seventy-seven contributors to the book either socially or professionally, and, when necessary, we were even able to call them at home with last-minute questions, so the compiling and gathering of material for that book was a comparatively painless process. With the success of that book, we were inspired to do a follow-up based on the visual art talents of musicians. The fact that we attended an art show in Los Angeles displaying the work of gifted musicians/artists only served to bolster our growing excitement at the prospect of collecting artists for this new book.

However, this time we were tackling a whole new breed . . . the professional musician. Although we had come into contact with many of these people over the years and we all share a brotherhood in the entertainment business, we are not full-fledged members of their fraternity and we felt a bit out of our depth. Naturally, we were aware of these musicians' considerable contributions to our pop culture and we were fans, but that, again, is totally different from dealing with them on a personal basis. Also, whereas actors are based primarily on the West or East Coasts, musicians are a necessarily peripatetic lot. The majority of them were touring during the preparation of this book, so conquering the logistical problems inherent in contacting these sometimes elusive people was a never-ending and, sometimes seemingly insurmountable, challenge. We had trepidations, but in retrospect, this has been a refreshingly pleasant lesson in destroying preconceptions

and myths perpetuated by the media. Little by little, as we spoke with these artists and found our rather precarious way into their world, we discovered, with not a little relief, that they were a delightfully unpredictable mixed bag of dedicated, hard-working, sensitive, caring, rather gentle individuals, totally committed to their work . . . the creation of music.

We soon found ourselves becoming aware of the link that exists between music and the visual arts. Whereas actors are primarily delineators, interpreters of the incipient creation—the script—the musician, like the painter, begins with his or her own version of an empty canvas—the silent room. That silence is molded, like the canvas, into an expression of fierce intensity, gentle romance, or rhythmic eruption. We believe that that correlation is evident in the art displayed in the following pages. What is revealed here is that, ultimately, whether these artists choose musical notes or paint to express themselves, they are channeling the same unique perceptions and experiences, and allowing the viewer—as well as the listener—to comprehend their world in a new way.

What most impressed us about these artists was how much they cared about their work, both musical and visual. They were eager to participate and hoped that this book would be something of which they could be proud. We hope that they are pleased with the final product. We certainly are.

We thank all of the contributors profusely for their patience, dedication, and cooperation.

—Jim McMullan and Dick Gautier

FOREWORD

I've always quietly held the view that there is a direct correlation between the visual and auditory arts. When I sit down to compose a film score, I translate the images that fill my eye and move my heart into musical terms that I hope will enhance what is happening up there on the screen.

Walt Disney's classic *Fantasia* was, I think, one of the best and (unfortunately) one of the very rare examples of artists turning sounds into visual images. The process can work in reverse as well; visual artists can turn images into sounds, can observe some frozen moment, be it idyllic, pastoral, or violent, and create a piece of music that clearly reflects or embellishes that mood.

Musicians, too, can switch mediums, transferring what they hear into what they see. This book is filled with fascinating examples of the results of such experiments. Over the years I have come into contact with musicians like Miles Davis, who had a flair for the visual arts. But in reviewing the art of the various modern musicians included in these pages, I was struck by the numbers of musicians who have kept their forays into the world of visual art a secret.

I have always been a lover of art in any form—visual, auditory, or literary—and I have nothing but respect for those who have the dedication to pursue excellence—quite often at the expense of luxury and personal comfort. The artists who grace these pages have not only distinguished themselves as gifted and successful professional musicians, but they have found the time to try to express themselves in another manner. In so doing, they've tapped a little deeper into their souls. And that requires not only patience and dedication, but courage.

—Quincy Jones

INTRODUCTION BY MICHAEL GREENE

Contemporary musicians are often viewed as creative savants: enigmatic individuals who possess a deep knowledge of one specific form of expression, yet are virtually helpless when they stray beyond their own peculiar artistic vocabulary.

This is a misconception, of course, one which unfortunately underlines how society consistently distorts, undervalues, and misunderstands those special, gifted souls who are our nation's greatest natural resource: our artists.

Musicians create harmony from dissonance, just as visual artists find unity in the interplay of shadow and light, or the contrast between stark simplicity and lush overstatement. It is their ability to reach beyond the obvious—to capture the most intense emotions in a phrase or a brush stroke, to take everyday objects or impulses into a higher realm—that remains a very precious and mysterious process.

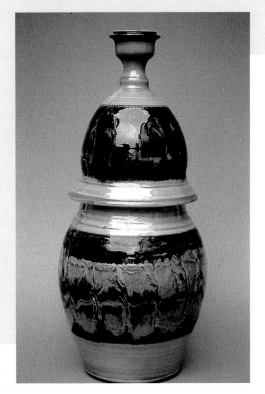

1

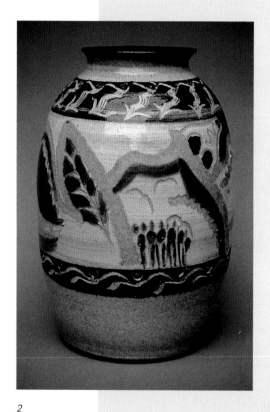

And when an artist successfully crosses from one creative domain into another (in the case of this book, from music into the visual arts) it's a wonderful feat, and one which is fortunately becoming more and more common. Through these pages you will marvel at how the physical embodiment of the artistic impulse provides shape and form that in many cases looks very much like the way the creator's music *sounds*.

Personally, having grown up as the son of a Big Band leader, it seemed that my artistic path was somewhat musically predestined. But I also felt a need to channel those creative energies into a more tangible form, and it was in the decidedly less frenzied realm of the ceramics studio that those ideas found physical form. My first undergraduate class in pottery remains as vivid a memory as the day my father sat me down at the piano and introduced me to a few of his

4

1. Blue porcelain bottle with carved design over cobalt slip
2. White and blue porcelain vase with carved textured surface
3. Granite stoneware with carved designs over various slips and glazes
4. Green porcelain covered vase with carved designs over cobalt and rutile slips

"secret" chords. Similarly, the moment I first touched the clay, I found myself transported to a very different place. I soon became totally immersed in pottery, spending virtually all of my free time in the ceramics lab throwing, decorating, and studying glaze chemistry. It was all another means of expression that, like music, gave me new ideas and a different point of view, not only about art, but more importantly, about life. (And, unlike music, there was the pleasure that came from taking a truly awful piece and crashing it into a million pieces, something far more satisfying than merely tearing up a lame lyric or lead sheet.)

Throughout my recording career, I would continually look forward to getting off the road and back into my ceramics studio. I've always felt that having access to diverse avenues of expression serves to strengthen one's artwork. And there's no better embodiment of that wonderfully symbiotic relationship between the musical and visual arts than the creations of the multi-talented artists found in this book.

On behalf of NARAS, MusiCares and our artistic family, thank you for your support and, by all means, enjoy this beautiful collection of art by our very talented musical friends.

Michael Greene
President & CEO
National Academy of Recording Arts & Sciences, Inc.

MUSICIANS AS ARTISTS

JON ANDERSON

Jon Anderson is a singer and songwriter with the group **Yes.** He is also known for his solo work and his collaborations with **Vangelis** and **Kitaro**.

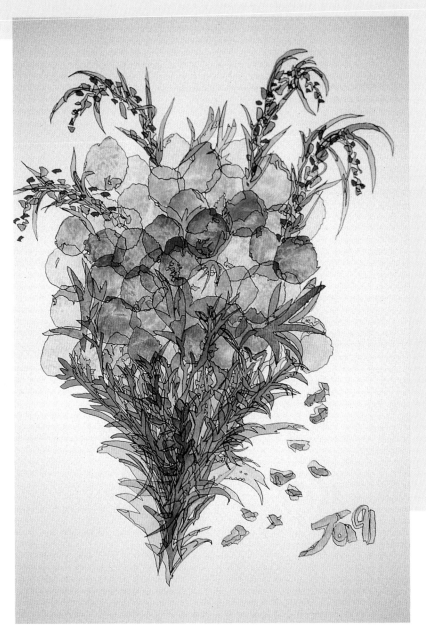

> *Art is the pure light of all there is. Art is the giving of freedom and love. Art is the true voice of all that is. Art is the link between God and man.*

Flowers, watercolor

JOAN BAEZ

1

2

1. *Easter Sunrise Service*, watercolor
2. *Out of the Night*, watercolor
3. *Morning*, charcoal pencil
4. *Ninner, Ninner, Ninner*, watercolor

Joan Baez was born in Staten Island of Quaker parents, which might account for her lifelong dedication to nonviolent activism and her commitment to individuals whose rights have been threatened.

Her music career began at the Newport Folk Festival where, at age eighteen, Baez made her professional singing debut. Her performance prompted one Boston music critic to describe her as having an "achingly pure soprano."

Within months of her debut, Baez's first record album was released, and she was touring college campuses. *Time* magazine did a cover story on her, and the Queen of Folk was on her way to becoming a significant voice for her generation.

During the sixties and seventies, Baez continued to sing while working as a civil rights and peace activist. She marched with Martin Luther King, Jr., supported the Farm Workers of America, and was jailed for her opposition to the Vietnam War.

In 1968 Baez met and married David Harris, a peace activist. A few months after appearing at Woodstock, Baez gave birth to their son Gabriel. Harris and Baez were divorced in 1972.

Over the course of her career, Joan Baez has given thousands of concerts. Eight of her albums and one of her singles went gold. She has received numerous awards for her humanitarian and her musical work. To date, she has over thirty solo albums and two autobiographical books to her credit.

In second grade, I drew excellent replicas of Bambi and charged my classmates two cents apiece for them. On my fourth grade report card, the teacher wrote that I was 'always entertaining the group' and that I had 'an unusual ability in art.'

By junior high school, I was drawing, rather than writing, most of my important assignments, from 'Mythology' to 'The History of the American Negro' to 'Human Hair: Growth and Characteristics.' Two things were accomplished. My undiagnosed dyslexia was circumvented, and the teachers—delighted at the originality of the work—awarded me high grades. I was soon drawing portraits of James Dean from movie magazines and charging five to ten dollars for them. People were particularly amused by my caricatures, and my classmates predicted that I'd be a cartoonist.

It is only recently that I have understood how important drawing was for me. Long before I had a singing voice, drawing was my greatest comfort. It released demons lurking in my unconscious, gave me joy and satisfaction and pleased others. Later on, singing would do the same for me.

I remember two early training experiences in art with gratitude. When I was thirteen, my parents treated me to a summer art class, which I loved. And years later, after I'd flunked out of theater school, I took a wonderful life drawing course and a course in contour drawing (where you look at the object you are drawing and not at what your hand is rendering on the page). Aside from that, I am basically self-taught.

Recently I have had the courage to try watercolors. I characteristically misuse them with results I find pleasing. I don't know if I will study further. I was told early on that I was misusing my voice. It was true, technically speaking, and now I train out of necessity. So while being a primitive in the arts has been deeply rewarding, learning from others might prove to be even more so.

3

4

PAUL BARRERE

The third son of character actors Paul and Claudia Bryar, Paul Barrere is a Hollywood-born and -raised talent. He attended several high schools before graduating in the summer of 1966. At Los Angeles City College, he was an art major, but rock-and-roll pulled him away from his studies. In 1972, after stints with various garage bands around town, Barrere joined **Little Feat**. In 1979 the group disbanded after the death of original band member **Lowell George**. They re-formed in 1987 and have enjoyed success ever since. Their recordings include *Let It Roll*, *Representing the Mambo,* and *Shake Me Up.*

1

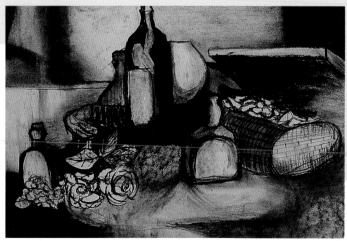

2

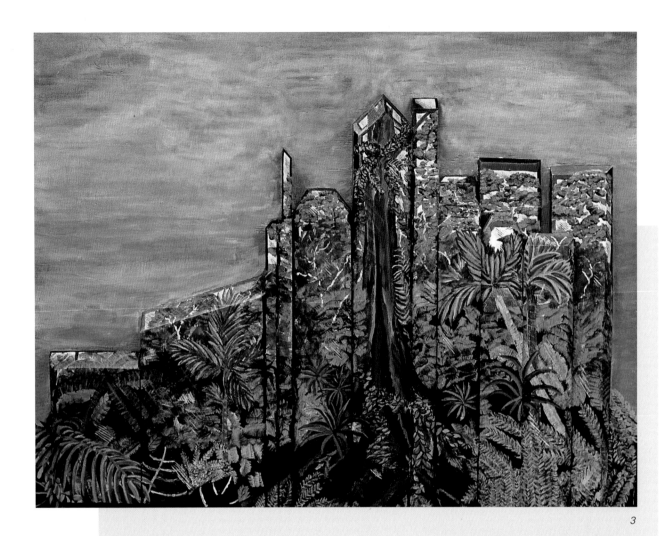

3

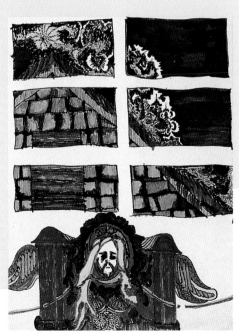

> *As an artist . . . I make an excellent musician. And, I must admit that it's a while between pieces. I have recently started to paint again, in acrylic, and have found that I am long on ideas and short on technique.*
>
> *My latest work is a combination of sculpture and paint, so it has a three-dimensional effect. I have, in the past, worked mainly in charcoal or pen-and-ink. The subjects have been mostly still lifes and nudes, but this new work is more conceptual and more ambitious than anything I have done in the past.*

1. *Owling at the Moon,* pen and ink
2. *Still Life,* charcoal
3. *Rainforest Reflection,* acrylic
4. *The Night That Dwane Died,* colored pen

4

PAT BENATAR

Pat Benatar was born in Brooklyn, New York, and began to sing as soon as she discovered she had a voice. Her first public appearance—at a church variety show—took place when she was eight years old. She honed her craft in the ensuing years and eased her way into the music profession. Her first "professional" appearance took place in 1972 at a Holiday Inn bar in Virginia.

Soon after, Benatar moved back to New York, where she was discovered at Catch A Rising Star. Her first hit "Heartbreaker" was followed by a string of gold and platinum recordings, including "Hell Is For Children," "Hit Me With Your Best Shot," "Love is a Battlefield," "Fire and Ice," "We Belong," "Invincible," and "All Fired Up." During this period, she met guitarist/producer Neil Giraldo. Married in 1982, they now have two daughters, Haley and Hana.

After winning four Grammy Awards, Benatar departed from rock and released the successful blues album *True Love.* Her eleventh album, *Gravity's Rainbow,* shows Benatar returning to her rock roots and her distinctive vocal style. It combines an aggressive approach with a certain amount of introspection, resulting in work that has the energy, passion, and vibrancy that has become Benatar's trademark.

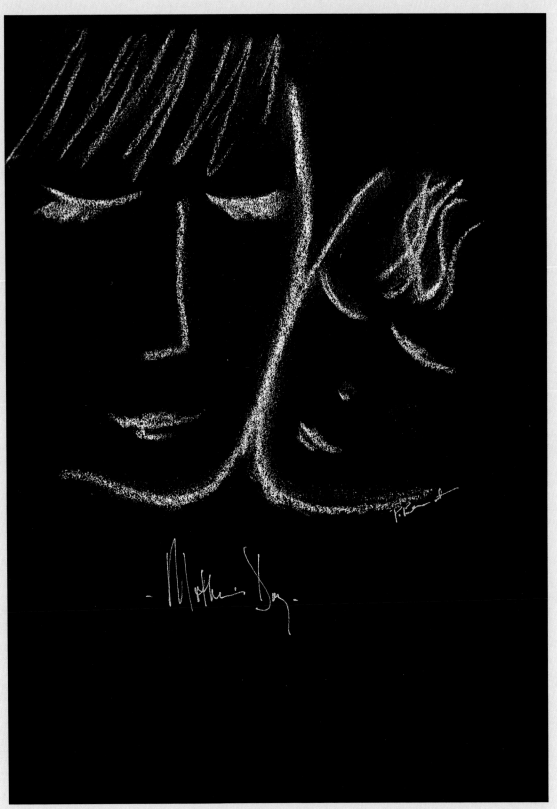

Mother's Day, charcoal

Life . . . the most spectacular gift.
Love . . . the dividend.

TONY BENNETT

"Tony Bennett is the best singer in the business, the best exponent of a song. He excites me whenever I watch him—he moves me."

—Frank Sinatra

The son of an Italian-born immigrant, Anthony Dominick Benedetto was born in New York City and grew up singing and drawing pictures. He spent three years in the Army in World War II, then began singing whenever and wherever he could. One night, Bob Hope heard Benedetto performing at the Greenwich Village Inn and asked him to do two things: one, join Hope at the Paramount Theater in New York; and two, change his name to the shorter, easier-to-remember Tony Bennett.

Soon Bennett was signed by Columbia Records and his professional career—or, as Bennett puts it, "his prolific adventure"—was underway. Bennett's classic style has proven timeless through over forty years of recordings and has even made inroads with the MTV generation. In 1994 the MTV network showcased Bennett on their award-winning "Unplugged" performance series. His albums and appearances continue to meet with unadulterated enthusiasm.

1

From his earliest efforts like "Boulevard of Broken Dreams" to his signature song "I Left My Heart In San Francisco," Bennett has produced work that makes him, as Frank Sinatra once said, "the best singer in the business, the best exponent of song." Bing Crosby has called him "The best singer I ever heard."

The distinguished Butler Insitute of Art in Youngstown, Ohio, which collects such American painters as Sargent, Homer, and Eakins, is planning a retrospective of Bennett's work.

1. *Homage to Hockney*, oil
2. *Duke Ellington*, oil
3. *Monet Garden #3*, oil
4. *Ralph Sharon*, oil

Although I'm known as a popular singer, I've always thought of myself as an artist. Even though I'm entering my fifth decade as a performer, I was drawing and painting long before I started singing.

One of my fondest memories is of sitting on the sidewalk creating a Thanksgiving mural with a set of chalks my mom had given me. As I was hard at work I noticed the tall shadow of a man standing behind me, admiring my efforts. 'I like that. Your work shows promise,' said the man, a Mr. James McWhinney, who was an art teacher who lived in my building. From that moment on, he took me under his wing and taught me all he knew about watercolor and painting. To this day, I attribute my passionate devotion to art to this man. Every time I pick up a paintbrush I feel the joy that was instilled in me by my first professor, James McWhinney.

Painting is becoming my second profession, but it remains my first passion. I feel blessed to be an artist and honored to be part of the brotherhood of painters. I consider them the best society in the world.

3

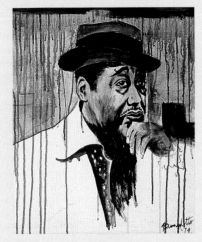

2

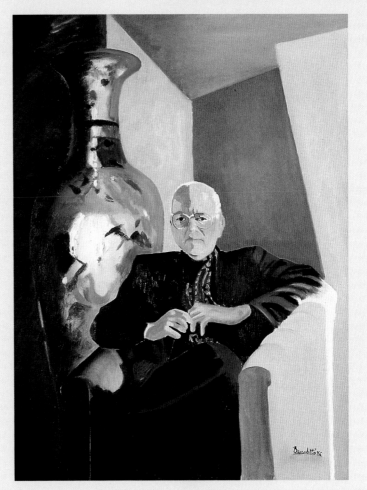

4

DERRICK BOSTROM

According to Derrick Bostrom, he was found intact on June 23rd, 1960, in the general proximity of his mother, Ida Mae Bostrom. His family traveled around the U.S. in a vehicle caravan, and during his formative years, Derrick lived at a succession of interstate rest areas. His schooling consisted of a series of beatings randomly administered. He was inspired to take up the drums after witnessing a riot in Paducah, Kentucky. He met **Cris and Curt Kirkwood** while panhandling. The brothers instantly offered him a job and the trio became the **Meat Puppets.**

Based in Arizona, the band has gained fame as an exciting, eclectic, and unpredictable act. Their albums—from *Meat Puppets* in 1983 to *Monsters* in 1989—and their live performances have brought them to the forefront of the alternative rock scene, prompting one reviewer to remark "As long as they're around, garage rock will be alive and well."

1

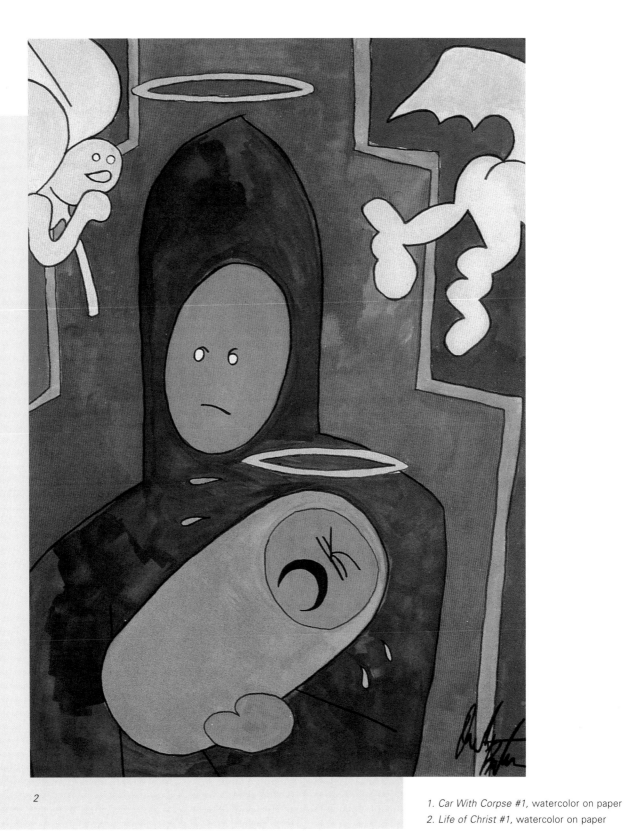

2

1. *Car With Corpse #1*, watercolor on paper
2. *Life of Christ #1*, watercolor on paper

Usually I only paint when I come up otherwise giftless during the off-Yuletide season. However, I did manage to find myself sufficiently inspired during Traffic Survival School attendance to produce a couple of pictures. The other two I knocked off to prove I knew something about art history.

DAVID BOWIE

David Bowie, singer, songwriter, actor, born London 1947.

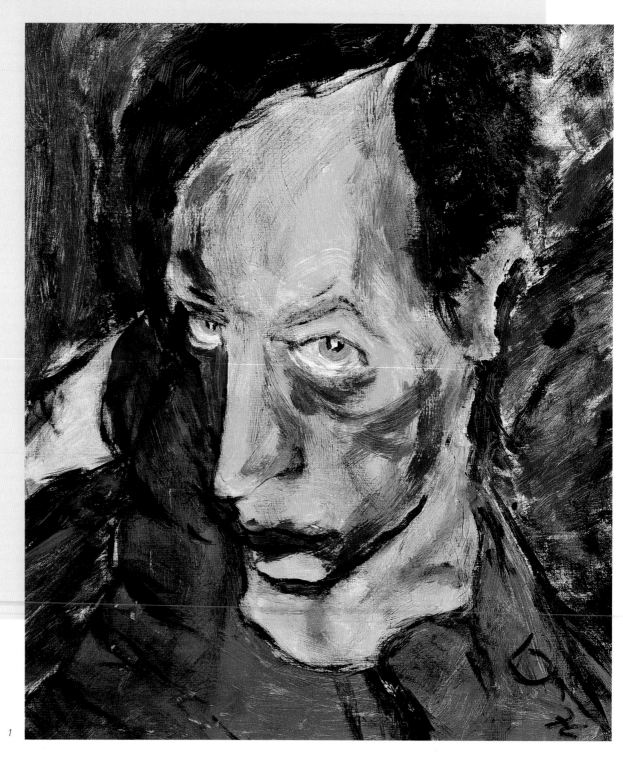

1

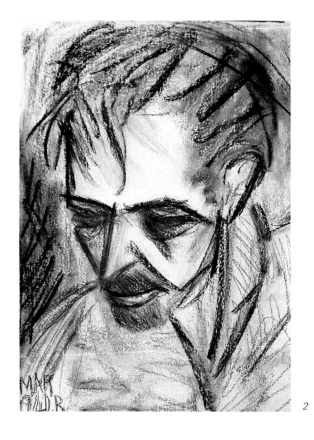

2

1. *Jim Osterberg*, acrylic
2. *Self-Portrait*, charcoal on rag
3. *Head of Sterling Campbell*, charcoal on rag

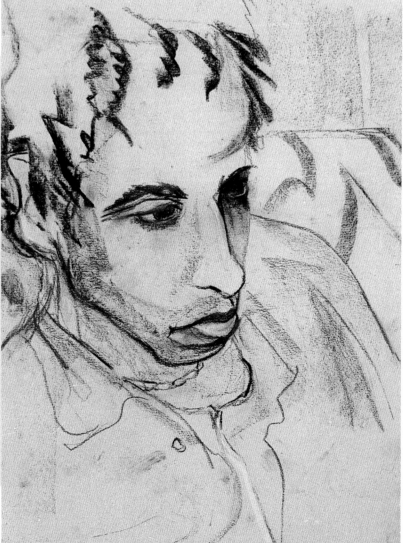

3

GEORGE BUNNELL

Perhaps it was because George Bunnell received private art lessons when he was four years old and studied art in school, that art and music have always made competing claims on his attention. But his art studies took a back seat to his music when he became a part of the band **Strawberry Alarm Clock.**

The band worked together for eight years before landing on the charts with their hit record *Incense and Peppermints.* After that success, Strawberry Alarm Clock continued to turn out gold and platinum records, including five Top 10 singles and six Top 10 albums. In their heyday the band members appeared in four movies, over three hundred television shows, and played thousands of concerts.

Bunnell and fellow band member **Lee Freeman** wrote most of Strawberry Alarm Clock's songs. Their hit albums included *World In A Seashell, Good Morning Starshine, Changes,* and *Strawberries Mean Love.* In 1983 the band re-formed with several original members.

1. *S.A.C. Debut of "Laugh-In,"* colored markers on poster board
2. *Manic Music as Therapy,* colored markers on poster board
3. *Here's Lookin' at You,* colored markers on poster board

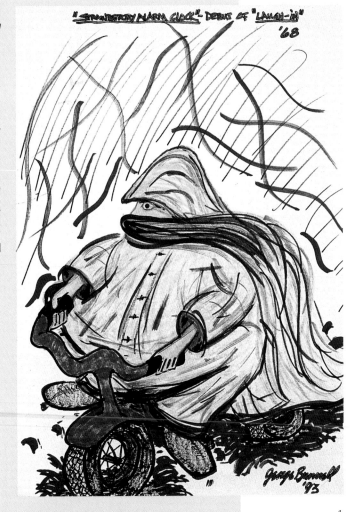

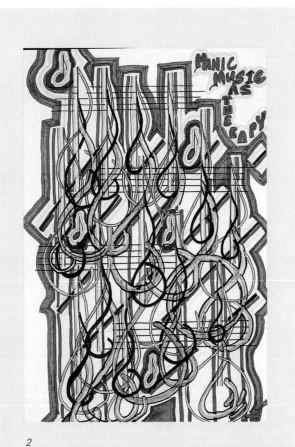

2

BALANCE. *This is what art represents to me. I can only go so far with music and then I need to create pictures and vice versa. One picks up where the other leaves off.*

THERAPY. Art and music give me a release. I can go wherever I want to go with them. There are no rules and no absolutes.

CONFIDENCE. Whenever I accomplish what I've set out to do, I'm ready to go again. It also affects the rest of my life. I seem to move up a notch each time I succeed.

SUCCESS. Comes with the territory. Whenever you're trying to achieve greatness, you might have success. Although it's nice, it's not a necessity. You can take it or leave it. Of course, I'd take it!

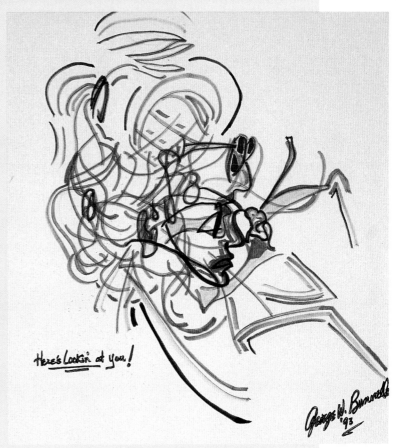

3

ERIC BURDON

Born in working-class Newcastle, England, Eric Burdon first became acquainted with and inspired by the gritty sound of American black music while still a teenager studying graphics and photography at art school. Unable to find a job, he temporarily turned his back on the art world and became a musician, joining the **Alan Price Rhythm and Blues Combo** in 1962. By 1963 the Combo had become the **Animals** and were turning out a string of hits, including "House of the Rising Sun," "Don't Let Me Be Misunderstood," and "It's My Life."

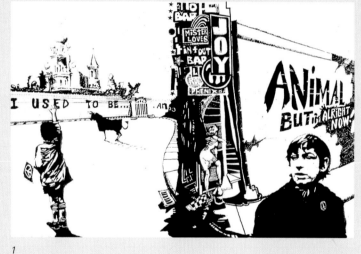

1

After several successful tours, the abrasive chemistry that made the band work finally precipitated its downfall. The band disintegrated only to regroup and form **Eric Burdon and the Animals.** The new Animals had their own series of hits: "San Franciscan Nights," "Monterey," "Sky Pilot," and "White Houses."

After the new Animals disbanded, Burdon retreated from the music scene to become a near-recluse in Southern California. He returned in 1970 to team up with **Lee Oskar** and form **War**. After recording albums with Oskar, Burdon starred in and composed the score for the German film *Comeback.*

Since then Eric Burdon has moved restlessly through the music business, performing at times with the **Eric Burdon-Robby Krieger Band** and the **Eric Burdon-Brian Auger Band.**

1. *I Used to Be an Animal, but I'm Alright Now,* pen and ink
2. *Chief Screamin' Eagle,* acrylic
3. *Bob Marley,* acrylic

Burdon continues to work in other mediums as well. He has starred in home videos, appeared on TV shows, and written an autobiography, *I Used to Be An Animal, but I'm Alright Now.*

❝ To me talking about art is like talking about religion. Unlike people who are indigenous to the South Sea Islands or, say, Guatemala, we Anglo-Saxons only label certain things as art. For me, what those other people do in their everyday lives is art. We need to put something in a frame and put it on the wall to call it art. The Japanese have made art out of the military; thus, the martial arts. American Indians have made art out of religious rituals. In Guatemala the way they paint a house is art.

That's where I have difficulty with the way that we view art. I had that problem when I was in art school. That's what drove me to rock-and-roll performance. We start out putting kids in art school and telling them that they're wasting their time if they want to be true artists. We tell them that to be an artist you have to starve and live in a garret. And so we push real artists into the commercial world.

That's what happened to me. Art school ruined everything I had as a kid. I found I slipped into rebellious modes in art school, because art school turned into a political forum about whether we could or could not have long hair and wear jeans.

3

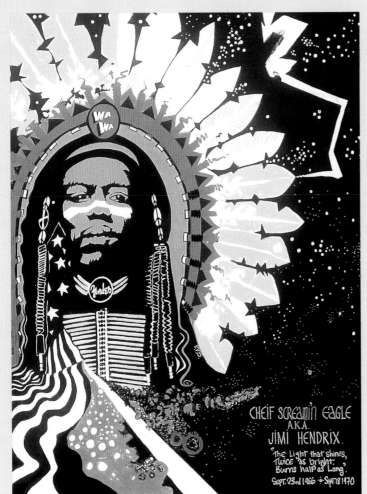

2

That's why I idolized Jim Morrison—the way he said that performance and art were secondary. Insurrection was the thing.

It all came together for me when I walked into the Dalí Museum. I suddenly realized who Dalí was, how much of a seer he was, a magician, how much of a joker he was. He really touched on religion. He embraced the commercial world; he didn't run from it.

If rock-and-roll would let me go, if I weren't tied to it, I'd pack up and go to Barcelona. It's where they all lived and worked . . . Dalí, Picasso, Gaudí. It was an experimental playground for artists. ❞

ROSANNE CASH

❝ I paint because there are many things, inside and out, which have no words.

Painting is the coffee shop where me and God meet for a cheese Danish. ❞

Rosanne Cash has been creating personal, deeply-felt music throughout her career. And it's no wonder considering her roots: she was born on May 24th at the very same time that her father, legendary singer **Johnny Cash**, was recording his single "Cry! Cry! Cry!"

When she was three, Rosanne moved with her family to California. By the time she was eleven, her parents had separated. Rosanne was subsequently raised by her mother, but maintained a warm relationship with her father.

Given that relationship—and a childhood spent listening to the Beatles, Joni Mitchell, Traffic, Blind Faith, and others—it's no surprise that the teenage Rosanne found herself interested in performance. She studied drama at Vanderbilt University in Nashville, and method acting at Lee Strasberg's Institute in Los Angeles. In the seventies Rosanne worked in her father's road show and for CBS Records in London. A chance meeting with Rodney Crowell at a party began her recording career. She first did an album (produced by Crowell) for a German company, then she signed with Columbia, her father's label. Rosanne and Crowell were married in 1979. Though they were later divorced, Crowell continued to produce her work.

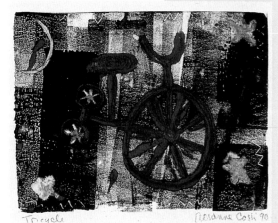

Tricycle Rosanne Cash 90

1

Combining her career with the raising of three children has not been easy for Rosanne. Still, while making her family a priority she has had considerable success with her albums, the Grammy-winning *Rhythm and Romance*, *King's Record Shop*, and *Interiors*. One of her most ambitious projects, *The Wheel*, is an incandescent album about how pain can be transformed into something valuable. To quote from that album is to understand something of what Rosanne Cash is all about:

1. *Tricycle*, monoprint
2. *Women of the Red Cross*, monoprint

I crawl through an abyss, I struggle and resist
Somehow I break free, someone becomes me
And when I stand upright I'm filled with a new light

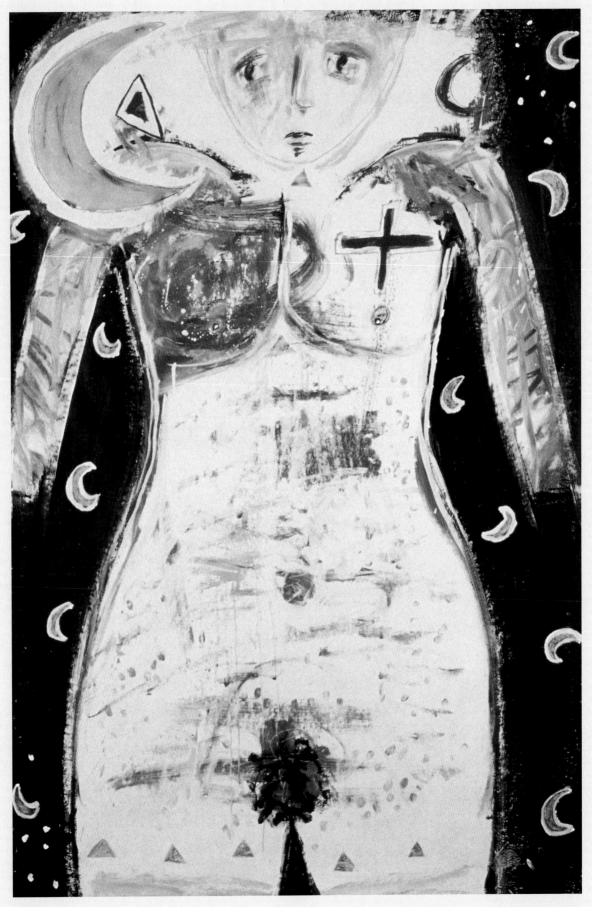

MICHAEL CLARKE

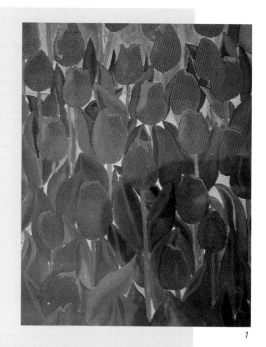

In 1946 Michael Clarke was born in Spokane, Washington, to a mother who was a pianist and a father who was an oil painter. He had, from the start, a predilection for the arts, and by 1963 he was ready to head for California to seek his musical fortune. That year, he met the other members of a group that would eventually become the **Byrds.**

After the Byrds turned out hits like "Mr. Tambourine Man," "Turn, Turn, Turn," and "Eight Miles High," Michael left the band. In 1968 he went into semi-retirement on the island of Maui, but retirement was not to his liking and Michael jumped back into the world of music by joining **the Flying Burrito Brothers.** Not long after, songwriter **Rick Roberts** joined the group. Eventually Michael and Rick broke away to form **Firefall.** That successful association lasted five years and produced the hits "Just Remember I Love You" and "You Are The Woman I've Always Dreamed Of." When Michael moved on, it was to play drums with **Jerry Jeff Walker**.

In 1984 Michael got together with his old best friend **Gene Clark** and reactivated the Byrds. Michael kept the group going after Gene Clark's untimely death.

Michael and the other members of the Byrds were inducted into the Rock & Roll Hall of Fame in 1991. Michael himself died before the completion of this book project. He is survived by his wife, Lee Elliott Clarke.

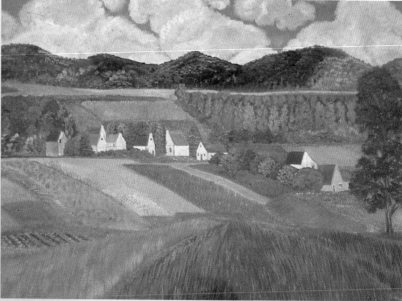

1. *The Tulips,* acrylic
2. *The Old Homestead,* acrylic
3. *My Friends House in Santa Fe,* oil
4. *Fields of Dreams,* oil

" In between hotels, motels, clubs, theaters, restaurants, cabs, limos, planes, divorces, and lawsuits I like to paint. After all, it saves on psychiatrist's bills and keeps me, for the most part, from curling up in a fetal position.

I like to paint outside on the bay or by the ocean (and catch supper at the same time). The land and seascapes inspire me to be a part of nature, to be with the breeze, the overwhelming sky, the burning sun, the chain saws, leaf-blowers, and police sirens. I find that biting gnats, attack seagulls, and lightning enhance the environment. (Infinitely safer than touring, trust me.)

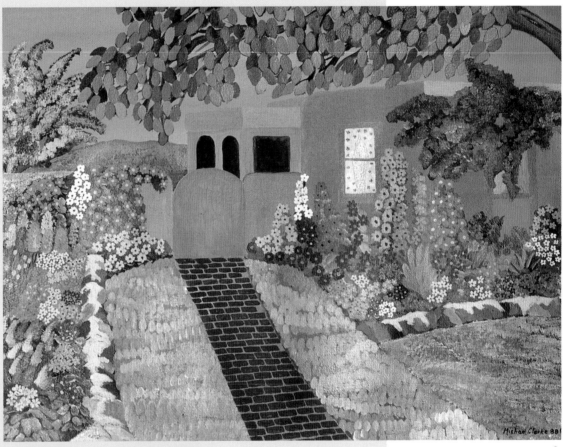

3

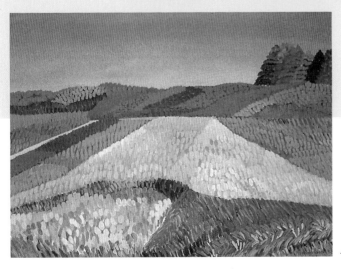

4

I love to paint the desert. I love the colors and to watch life thriving despite itself.

Writing has always been a fantasy of mine but music and painting come first.

My father was an artist and my mother was, and still is, a fine jazz piano player. So I guess it was meant to be. My grandmother played piano at the old movie houses for the silents.

But what all this has to do with me I don't know just yet. "

JUDY COLLINS

1

Judy Collins was born in Seattle, Washington, and grew up with music as the focal point of her existence. At age five she began studying classical piano. She often joined her father—Chuck Collins, a well-known radio personality—to perform Gershwin, Porter, and Rodgers and Hart on his program.

When she was eleven, Collins's family moved to Denver. She continued her piano studies, and by the time she was thirteen, she was playing Mozart for audiences. Two years later, when she was fifteen, she discovered folk music and set out on a new musical path.

Judy Collins sings songs that are spiritual yet earthy, sophisticated yet folksy. She's been called "a national diva," "America's balladeer," and "the voice of her generation," and has had gold and platinum records. Some of her better-known interpretations include "Send In The Clowns," "Amazing Grace," "Both Sides Now," and "Chelsea Morning." Her own compositions include "My Father" and "The Blizzard." The progression of her work—from traditional ballads to protest songs to tunes for the theater—demonstrates her considerable range.

Collins is known for her commitment to a number of causes. She has worked in the peace movement and for abortion rights. She is dedicated to ending world hunger, saving the environment, and raising money for AIDS and leukemia research.

Collins's *Trust Your Heart: An Autobiography* was published in 1987.

2

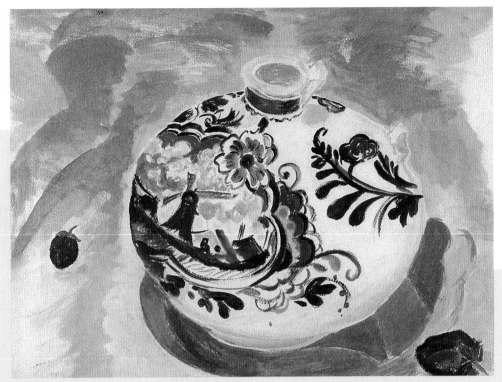

3

4

> Discovering watercolors has enhanced my ability to listen to music and has allowed me to find an alternative voice for my creativity. As Henry Miller said, 'To paint is to love again.'

1. *Eze Terrace with Red Flowers*, watercolor
2. *Time in Arles*, watercolor
3. *The Ginger Jar*, acrylic
4. *Susie's Plate*, acrylic

ALICE COOPER

1

2

Some call him the master of shock rock. Others think of him as a supreme black humorist. Either way, Alice Cooper is certainly a distinctive showman.

Debuting in 1970, he turned the music business upside down by wearing outrageous clothing and gruesome makeup and performing hard rock with disturbing lyrics. His many gold and platinum albums include hit songs like "I'm Eighteen," "School's Out," "Trash," "No More Mr. Nice Guy," "Only Women Bleed," and "Poison."

Alice Cooper brought show business and rock-and-roll together in new and original ways. His concerts are large-scale events where the stage is often furnished with a guillotine, an electric chair, or a gallows. Cooper is invariably the victim of these props and the playmate of the live snake that often joins him on stage. His ABC-TV special "Welcome To My Nightmare" was essentially the first extended video album.

Cooper continues to record and tour. He has had guest appearances in several films and TV shows, including the hit comedy *Wayne's World*.

1. *Untitled,* acrylic
2. *Self Portrait '93,* pencil sketch
3. *Force Feed,* ink sketch
4. *Untitled,* acrylic

3

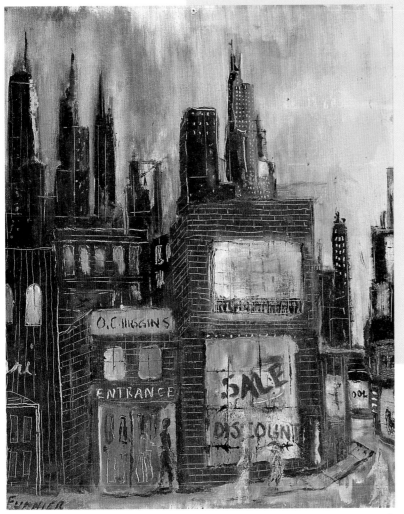

" I was actually an art major in school. I always attended classes when I wasn't suspended.

Surrealism has always been a big part of the Alice Cooper show. What we do is take surreal images and bring them to life on stage.

My two main influences in art have been Yves Tanguy and Salvador Dalí. One of the greatest times of my life was when I worked with Dalí. I was the model for the world's first 360-degree moving hologram, which he created. It included a sculpture of my brain with a soft watch and a chocolate eclair with ants crawling on it. I thought it should have been called 'Food For Thought.' It's on display at the Dalí Museum. "

4

MICHAEL COTTEN

Michael Cotten has dedicated his life to the arts, experimenting with music, theater, film, video, graphics, interior design, and painting. During his high school years in Phoenix, Arizona, Cotten developed an interest in architecture, which led to an apprenticeship at Paolo Soleri's Arcosanti studio.

Later, he made some experimental 16mm rock music films that gained him admittance to the San Francisco Art Institute's film department. While in school, he discovered the synthesizer, and soon after, he and six friends formed the theatrical rock group the **Tubes.**

The group signed with A & M Records then toured and recorded for ten years. Cotten and drummer **Prairie Prince** collaborated on nine of the group's album covers and worked with director Kenny Ortega on the group's videos. Cotten and Prince also did design work for businesses. They painted gigantic murals for A & M Records, Chemical Bank of New York, The Limited, Macy's, and others.

When the Tubes disbanded, Michael moved to New York to pursue painting and production design full-time. Since then, he has designed shows for **Bonnie Raitt**, **Gloria Estefan**, **Kitaro,** and **Run DMC** and has done work for Mazda Cars, Compac Computers, and McDonalds. He also executed a series of super-realistic paintings in acrylic which have been sold to private collectors.

His most recent works are abstract panels covered with twenty-two carat gold leaf. They represent Cotten's exploration into the creation of works that will be unaffected by the ravages of time.

1

2

1. *Public Enemy*, acrylic on canvas
2. *Rooster*, acrylic on canvas
3. *Atomium*, acrylic on masonite
4. *Square Tube*, acrylic on canvas
5. *Just Ice*, acrylic on canvas

3

I consider all my work to be a form of self-portraiture.

4

5

MILES DAVIS

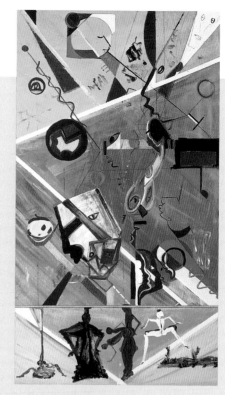

1

Miles Dewey Davis III was born on May 26th, 1926, in Alton, Illinois. At the time of his death in September of 1991, he had received many of the awards that the music industry offers as well as a wealth of other honors. He received an honorary doctorate of music from the New England Conservatory in Boston in 1986. In 1988 he was knighted in Spain by the prestigious Order of Malta— thereby becoming Sir Miles Davis, Knight of Malta. Three years later, in July of 1991, the French Ministry of Culture conferred the title of Chevalier de la Légion d'Honneur on him.

Davis's recording career spanned over forty years, starting in 1950 when he released his first album, *Birth of Cool,* and ending in June of 1992, when Warner Brothers released *Do Boop,* an album Davis was working on shortly before his death. Only three months after its release, this final album had a place on the Billboard Top 100, Rhythm and Blues, Jazz, and Rap charts. It was the first time a jazz musician had appeared on charts for so many different types of music simultaneously.

During his lifetime Davis was nominated for Grammy awards twenty-six times. He won the award six times. In February 1990 he received the Lifetime Achievement Award from the National Academy of Recording Arts and Sciences. *Miles: The Autobiography* was published in 1989, and *The Art of Miles Davis* was published in 1991.

The first exhibition of his art work was held in the United States in 1989. Subsequent exhibitions took place in Japan, Germany, Switzerland, and Italy.

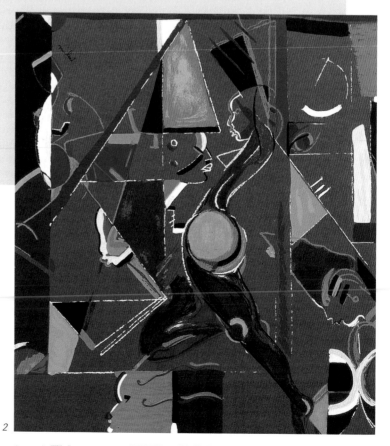

2

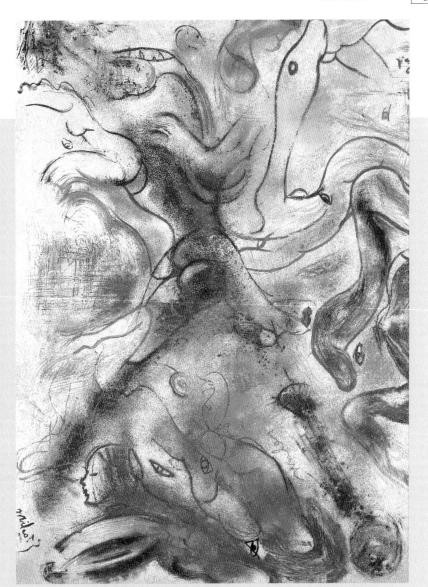

Art is like therapy for me and keeps my mind occupied with something positive when I'm not playing music.

I've been painting and sketching all my life. As a kid I did comic book faces which could be turned upside down to get something different.

You'll see a lot of eyes in my work, 'cause eyes make the whole character. I like 'em when they're old, slick church women when someone is talking and . . . they're rolling their eyes. If I'm doing one of my totem poles, I might have different faces looking different ways.

If I have a canvas, I look at it like I would an arrangement. It has to be balanced. I have to have something going this way, something going that way . . . contrary motion from maybe two melodies . . . balanced and modern.

It's got to come from within or it's not there.

1. *Untitled,* serigraph
2. *Josephine Baker,* serigraph
3. *Sea Horses,* serigraph
4. *Self Portrait,* serigraph

3

4

MICKEY DOLENZ

Born in Los Angeles, Mickey Dolenz is the product of a show business family. His father, George, starred in a number of films and played the title role in the TV series, "The Count of Monte Cristo." As Dolenz grew, it became obvious that he would follow in his father's footsteps. When he was ten, he starred in his first TV series, "Circus Boy." After three years, Dolenz guest-starred on other TV programs and learned to play the guitar and sing hard rock. When he auditioned for the **Monkees,** he sang Chuck Berry's "Johnny B. Goode." Out of over four hundred applicants, Dolenz was one of four selected to be in the Monkees.

The group's debut single was "Last Train to Clarksville," and it featured Dolenz on vocals and drums. (Dolenz had to learn how to play drums to be in the group.) The single hit the charts and went straight to the top. Two days later the TV show debuted, and eventually it, too, placed high in the ratings. Dolenz was twenty-one and a star. "The Monkees" remained high in the ratings for two years.

When the group split up, Dolenz went to London to perform. He intended to stay in England for three months but ended up living there for twelve years. During that time, he became a prominent director/producer for the BBC and London Weekend Television. When "Monkeemania" hit in 1986, Dolenz became a performer and recording artist once again. The Monkees had a popular reunion tour in 1989, but since then Dolenz has been a solo performer. His debut album as a solo act was *Mickey Dolenz Puts You To Sleep.*

From acting and recording to directing and producing, Dolenz has an enthusiasm for the entertainment business that has only grown over the years. Dolenz now says, "I used to be known as the singing drummer, then the singing director. Right now, I'm having fun as the singing actor."

Connection, acrylic

I do careful research for my art—not to ensure that my images are technically accurate but to ensure that they are aesthetically so.

A few years ago, while studying physics in England, I was struck by the beautiful images captured by the electron microscope, and those images are what I am depicting. I describe my work as 'still life of things you can't see.'

PERRY FARRELL

Perry Farrell, one of the foremost musicians in the alternative rock scene, was born in Queens, New York. After finishing high school in Miami, he moved to Los Angeles and started the band **PSI COM**. When they broke up he joined with **Eric Avery** and **Dave Navarro** and the trio became **Jane's Addiction**.

In 1990 Jane's Addiction won *Performance* magazine's Club Tour of the Year award; in 1991 they won "Best Alternative Video of the Year" for "Been Caught Stealing," and their album, *Ritual de lo Habitual,* went gold. Farrell himself was named Artist of the Year by *Rolling Stone* in 1992. The energy that made Jane's Addiction an exciting band, however, also caused their separation. When the group members went different ways, Farrell formed **Porno for Pyros,** another cutting edge alternative rock band.

Farrell is the creative force behind and founder of the Lollapalooza concert tour, an annual summer showcase for alternative rock music.

1

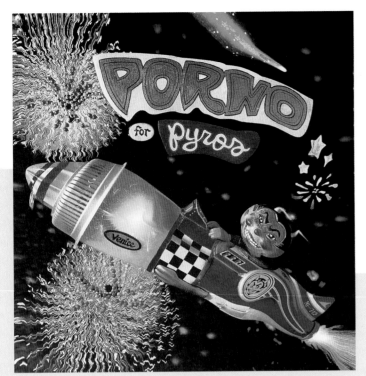

2

Art is the ultimate drug.

1. *Nothing's Shocking,* mixed media
2. *Porno for Pyros*, mixed media
3. *Ritual de lo Habitual,* mixed media

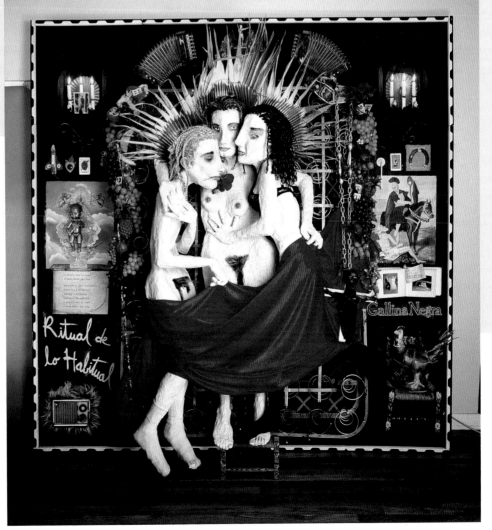

3

DAN FOGELBERG

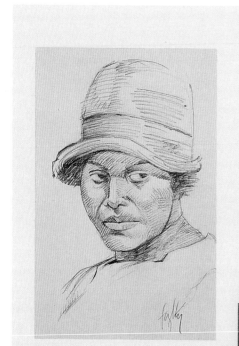

1

Dan Fogelberg, long regarded as one of contemporary music's most eloquent voices, started his music career as a little boy diligently practicing the piano in Peoria, Illinois. By the time he'd reached his teens, Dan was playing guitar as well. He studied art at the University of Illinois and began to perform his music in local coffeehouses.

Not long after college, he was signed by Columbia Records and his first album, *Home Free,* was released. Two years later, when his second album, *Souvenirs,* was released, his career was established.

This initial success was soon reinforced by the success of the albums *Netherlands* and *Twin Sons of Different Mothers,* which went platinum. Tunes like "The Power of Love," "Longer," and "Language of Love" have been particularly popular with fans.

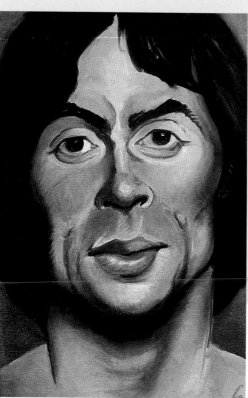

2

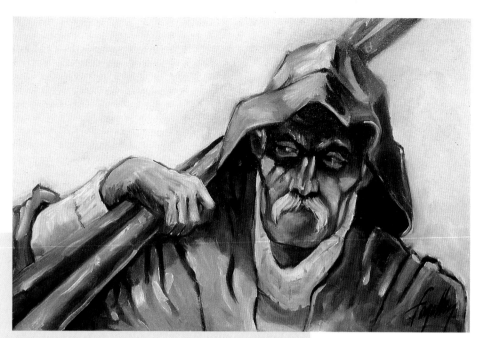

3

> *To me all art springs from the same place, the same well of inspiration, if you will. Drawing and painting are merely a different medium with which to reach that creative center.*
>
> *Even after a lifetime of creating and appreciating art and music, I am still unable to explain, either to myself or others, the essence of that mystery.*

4 *5*

1. *Untitled*, charcoal
2. *Nureyev*, oil
3. *Old Fisherman*, oil
4. *Untitled*, charcoal
5. *Self Portrait,* pencil

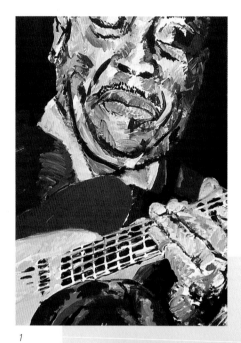

1

2

George Frayne has been involved in the visual arts since childhood. He graduated from the University of Michigan with a B.A. and later an M.A. in sculpture and painting. During that time, George was also playing with the original **Commander Cody Band**, so following grad school he had to make a big choice . . . art or music. After much soul searching he accepted an offer to teach sculpture, design, and figure drawing, but as the year went along he found himself stifled by the academic atmosphere. When he left academia, members of Commander Cody urged him to move to the West Coast and pursue his music. Frayne did so, abandoning his art work in the process.

In San Francisco, Commander Cody caught the tail end of the psychedelic scene and packed clubs every night until they were signed by Paramount Records. Their first album, Lost in the Ozone, had a Top 10 single with "Hot Rod Lincoln."

Commander Cody toured and recorded four more albums for Paramount and three for Warner Brothers before disbanding in 1976 after a long European tour. Since then, the band members have gone in different directions. George Frayne continues to make music, but he has, at last, returned to creating visual art.

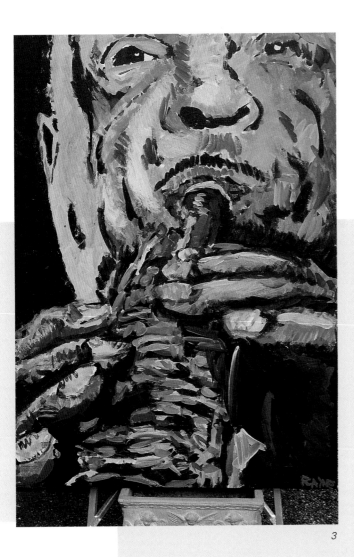

1. *Muddy,* acrylic
2. *Ode to a '58 Mercury,* acrylic
3. *Sidney Becket,* acrylic
4. *Dizzy,* acrylic

3

“ *The two most important parts to doing a painting are to:*

—make sure your brushes are clean . . . always have at least one can of fresh water available. It's OK to muck around with a dirty brush in the middle stages of a work, but at the start and the finish, you want your brushes clean.

—know when to stop. The hardest thing for a painter is determining when the work is finished. . . . At least this is what I used to tell my students. ”

4

LEE FREEMAN

Lee Freeman is a many-faceted musician and artist, best known for being one of the founders of **Strawberry Alarm Clock**. He plays many instruments and is responsible for composing many of Strawberry Alarm Clock's most popular songs. He has always had a deep interest in the visual arts.

Freeman started his musical education at age four. His father was an amateur musician who played the saxophone, guitar, and pedal steel guitar. Freeman held his first union card when he was eleven years old, just one year before he formed his first band, the **Victors**. He hit it big with a song called "The Sixpence," which became the number one song on local music charts. After that, the Victors changed their name to Strawberry Alarm Clock and began touring and recording. They made the music charts with their record *Incense and Peppermints*, and went on to turn out gold and platinum records, including five Top 10 singles and six Top 10 albums.

Freeman's talents are wide-ranging. He plays guitar, harmonica, keyboards, dulcimer, bagpipes, sitar, and tabla. He sings, arranges, and writes. He is also a gourmet cook, a tinsmith, an animal handler, a father of two, a cobbler, and a second-degree black belt. Since Strawberry Alarm Clock disbanded, Freeman has played with **Lynyrd Skynyrd**.

When asked what he's doing these days, Freeman says, "Still working on it all."

1

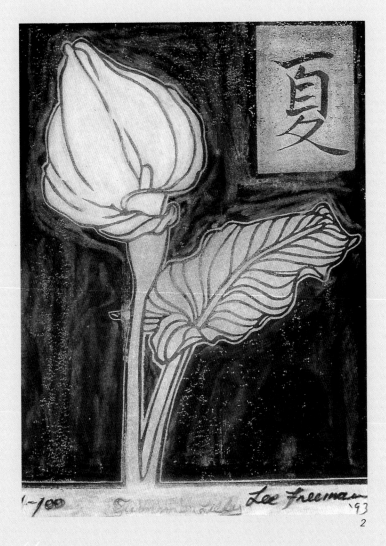

2

3

1. *Blackie—1958 Stratocaster,* wood carving
2. *Summer Lilies,* block print
3. *Untitled,* clay
4. *Self Portrait,* block print

" My outlook on the field of art has always been one of full speed ahead. Time invested in projects gains results. Be it music, art, or some other medium. The time invested is the important part of the construction. The rest must be left to the eye of the beholder. To capture oneself in the process is the process. One must allow thoughts, actions, and words to come into order, to fall into place—perhaps to please the eye, the ear, the senses.

My background is one of what some would consider complete turmoil. Left to fend for myself at an early age, I took to the world of thought. Learning to understand the language of this world led to understanding how to create music.

Clay is just that till the person holding it sees beyond it. To mix sound with words is the same as mixing color with paper.

Music fills my life with joy. My art satisfies my soul. "

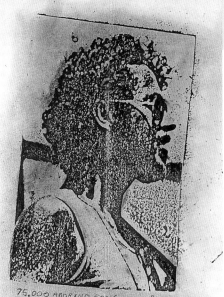

4

JOHN FRUSCIANTE

Guitarist John Frusciante was born in Kew Gardens, New York. After leaving the **Red Hot Chili Peppers**, he recorded a solo album called *Niandra Le Des—Usually Just A Shirt*.

His favorite artists are Duchamp, da Vinci, Basquiat, and Clara Balzary.

1

1. *Untitled,* oil stick and acrylic
2. *Untitled,* watercolor and pastel
3. *Untitled,* by John Frusciante and Clara Loesa Balzary, acrylic, oil stick, and pencil

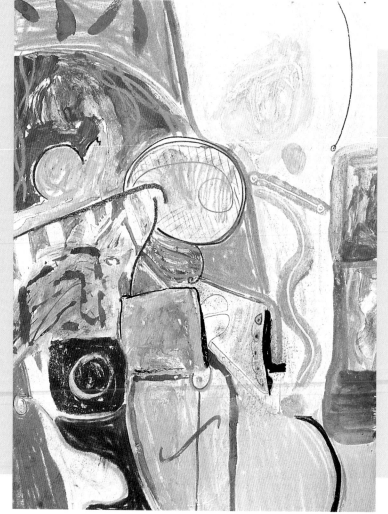

2

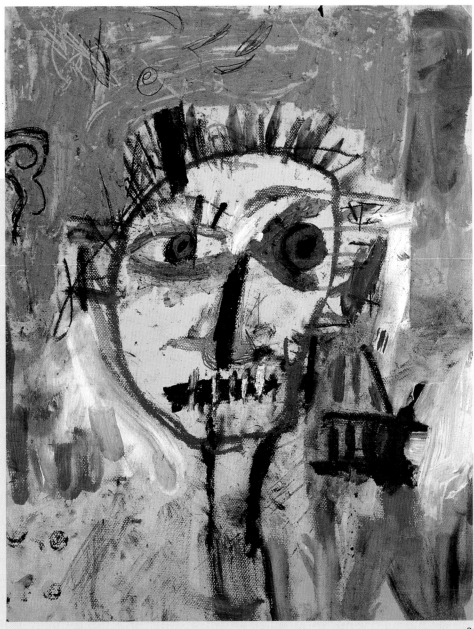

3

Art = Arte as shit = SHITTE
 —Duchamp

The only thing we have to do with art is it's the last three letters in FART.
 —Gibby Hanes of Classical Butthole Surfers.

I agree and disagree, in the sense that I am nothing, and anything that amounts to zero is beautiful and overwhelming to me. Art doesn't exist, but neither does the moment that this sentence began. Come back with me now. I believe 1,000,000 = zero as obviously as does 1 0 0 0 0 0 0.

Words are an infinite vagina that flips inside (out) itself (its surroundings) into the 4th dimension. Art is my or your surroundings, and is, therefore, just a question of being everywhere and nowhere or being a bum on why. "

JERRY GARCIA

Jerry Garcia attended the San Francisco Art Institute, where he studied with Wally Hendrick and Elmer Bischoff in the late fifties. Concurrently, he was playing guitar and singing in small clubs in the North Beach section of San Francisco. Music eventually sidetracked his fine arts pursuits and he went on to form the **Grateful Dead**. As lead guitarist and vocalist of the band, Garcia has attained a status of near mythic proportions, with an almost cult-like following of "Deadheads." Garcia and his band have cut over thirty albums and have been touring the world for the past thirty years.

Garcia has been painting and drawing for his own pleasure since the fifties. It was not until 1991, with his first gallery exhibition, that he began showing his art work. Galleries around the world have exhibited his "sold out" art shows. Garcia's images can also be seen on his own line of wearable art—silk ties. President Clinton, Vice President Gore, and the Chicago Bulls coach, Phil Jackson, have worn the popular neckwear.

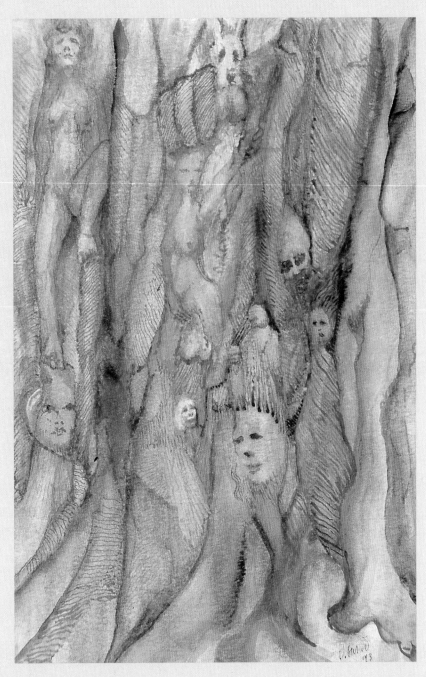

Who Goes There?, watercolor

" *I've been doing this [painting] longer than I've been playing guitar.* "

PETER HIMMELMAN

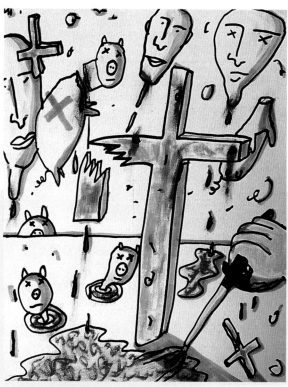

1

Minnesota-born Peter Himmelman started playing saxophone in the fifth grade. Soon he moved on to the guitar and started organizing bands. His first group, the **Reflections**, earned five dollars a gig. When that band dissolved in the sixth grade, Himmelman started another called **Birch** that played school dances and bar mitzvahs throughout Himmelman's junior high school years. Music wasn't something Himmelman originally intended to pursue, but, he says, "every week there was a new and sweeter carrot out there."

After high school, Himmelman signed on as the youngest member of **Changoya**, a reggae calypso band in Minneapolis. Himmelman stayed with the group until he was nineteen. Then he reorganized his grade school musician pals and formed **Sussman-Lawrence**. They played together for two years, moving to New York in 1984 and changing the band's name to **Peter Himmelman**. The group specialized in tongue-in-cheek pop music.

In the mid-eighties Himmelman established himself as a solo artist by writing and performing an album dedicated to the memory of his father.

Among other accomplishments, Himmelman composed and recorded instrumental music for the movie *Crossing the Bridge*.

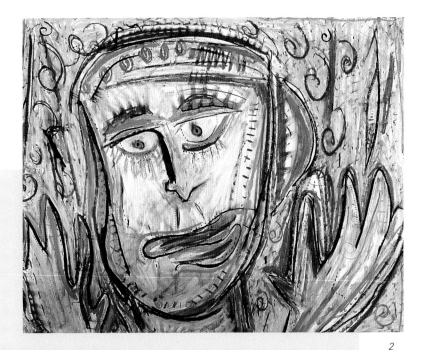

2

I always liked to draw. When I was a kid, my uncle owned a printing shop, and I got to use the large sheets of paper he had there.

My mother really encouraged me in my drawing. She loved art. She used to take me to museums, so I could see the work of various artists.

I abandoned my art for music, but the art still comes out in sporadic clusters. I prefer drawing to painting. I enjoy using turpentine on oil pastels. It kind of blows the colors up, gives them an interesting look. I like the feeling of the utensils in my hand.

Sometimes I bring paper and crayons or colored pencils to my show. I hand them out to the audience and encourage them to draw during the performance. Some really phenomenal stuff comes out of that experience.

Crayons and pencils are such kid things—they're such kid-smelling and -looking things—that they put you in touch with the childish side of your nature.

3

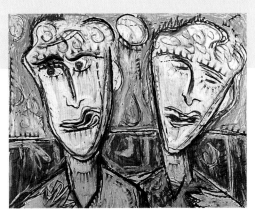

4

1. *Chaos and Void,* watercolor
2. *Anxiety is Yellow,* oil and pastel
3. *In Larry's Head,* watercolor
4. *Best Friends on a Tuesday Afternoon,* oil and pastel

CRIS KIRKWOOD

Cris Kirkwood was born October 22nd, 1960. As a child he dreamed of being a woodcutter, but that dream was shattered by an unsettling experience during the viewing of a television program. That's all anyone can get out of him. Married to a third cousin in 1971, Cris took up bass playing as an excuse to get out of the house. He resides in Tempe, Arizona, and counts among his favorite things: his whistle collection and the concept of neural pathways.

Kirkwood, his brother **Curtis**, and **Derrick Bostrom** formed the **Meat Puppets**, a band that has been ignoring artistic boundaries since its inception in 1980. Songs like "Sam," and "Backwater" have earned them a solid following among alternative rock fans.

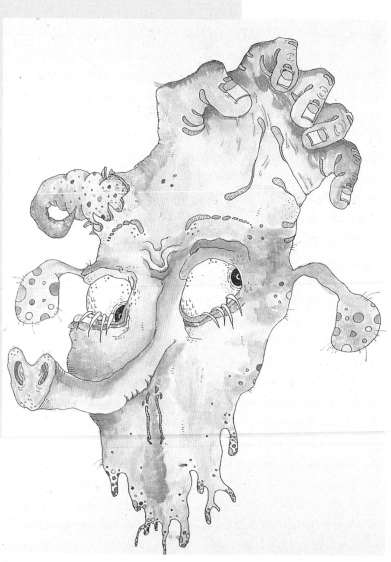

Art comes naturally to me. Without it, I'm nothing.

1. *Interdependent Lung Exchange,* watercolor and ink on paper
2. *Brown Lightly, Garnish & Serve,* watercolor and ink on paper
3. *My, You Have a Nice Kitchen,* watercolor and ink on paper

CURTIS KIRKWOOD

According to Curtis Kirkwood, the gods were smiling on that day, January 10th, 1959, when he was born. He had a head of luxurious, wavy, brown hair, fully functioning digits on both his hands and his feet, and orifices into which food entered and was expelled. He showed a proficiency for forming pat, unfair judgments about the people around him. He was a fast bloomer, achieving full adulthood by the age of six— at which time he challenged his father to a duel to the death. Upon winning, he formed the **Meat Puppets**, an organization which, to this day, inspires disappointment and indifference in thousands.

1. *Pee Pee,* acrylic on canvas board
2. *Can of Pez Jelly,* acrylic on canvas board

1

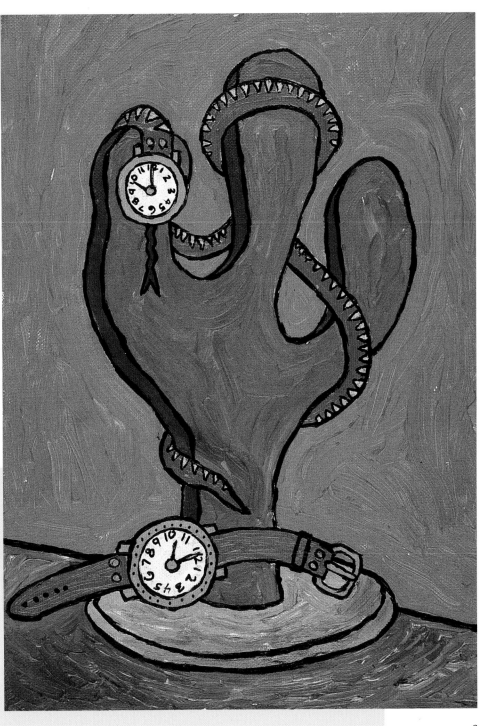

2

I like to paint, because it's so stupid and that's what makes it signifi-
cant and important. I enjoy the contradiction of terms.

ROBBY KRIEGER

The beginning of 1993 saw Robby Krieger and the other members of the **Doors** inducted into the Rock & Roll Hall of Fame—no surprise given that some of the greatest rock music of all time came from Krieger's pen. While he was lead guitarist with the Doors he wrote "Love Me Two Times," "Touch Me," and "Light My Fire."

Krieger was born and grew up in Los Angeles. He attended the University of California at Santa Barbara for a short time and, while there, he met some musicians at a meditation class. Soon after, they formed a garage band and the Doors were born.

The Doors' reign in the world of rock-and-roll is now legendary. After the band fell apart, Robby's music career continued. With the Doors' drummer **John Densmore**, he assembled a group called the **Butts Band**. They produced two successful albums and were the first American group to do reggae music.

Krieger has also recorded *Robby Krieger and Friends*, *Versions*, and *Robby Krieger*. All three albums have the inventiveness and mysterious spirit that was the cornerstone of the Doors' work. More recently, Krieger has started to incorporate jazz licks into his work—a trend that has breathed new life into his music.

In 1990 Krieger joined **Eric Burdon**, formerly of the **Animals,** to tour the United States. After the tour, Krieger formed a new group, the **Robby Krieger Organization**.

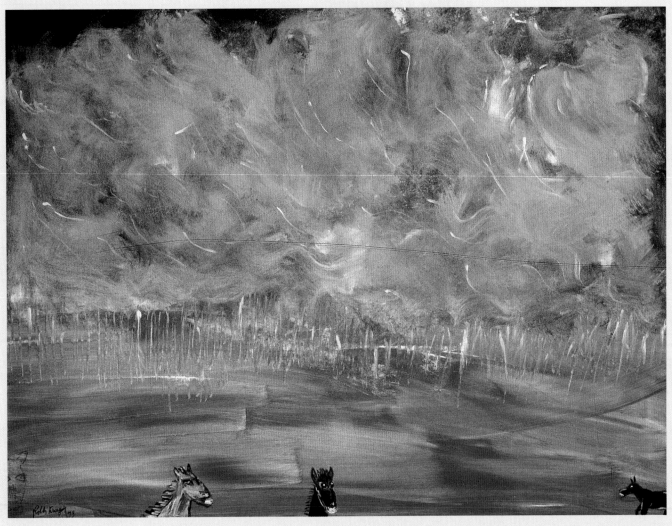

Horse Latitudes, acrylic

66 *I always liked to draw. I started when I was a kid, and I was pretty good at it. My dad was an aeronautical engineer. He was one of the guys who worked on the Flying Wing, so I got interested in machines and machinery in an artistic sense.*

My mother was interested in art, and I got interested because I had access to her paints. But when I got involved with the Doors, I kind of dropped art for a while. Then, a few years ago, some charities asked me to contribute some art work, so I got interested in painting again. Now I paint about once a week if time allows. I paint differently now. Now, it's more stream of consciousness . . . sort of psychedelic. I'll start slopping a bunch of paint on the canvas and see what evolves. Then I kind of go from there. 99

PETER LEWIS

As the son of producer Tom Lewis and film star Loretta Young, Peter Lewis's musical career is, in some ways, a result of his parents' marital difficulties. After his parents split up, the teenage Lewis was upset, and he turned to a New York hospital for help. Hospital staff prescribed the guitar as therapy, and Lewis has been playing ever since.

Peter formed his first band, the **Cornells**, when he was fourteen. The band lasted five years, breaking up only when Peter enrolled in a pilot training program at Purdue University.

Eventually, Lewis's love of music superseded his love of flying, and after a short stint with **Peter and the Wolves**, he joined **Moby Grape**. A somewhat turbulent career followed.

A trip to Paris inspired Peter's interest in the visual arts. Pursuing this interest with his usual fervor, he went back to school, graduating in 1989 from the University of California with a B.A. in drawing and painting.

He continues to both paint and make music.

1

1. *Zero Mostel*, oil on canvas
2. *In the Land of Milk and Honey,* acrylic

I have heard that sounds have color. This . . . can be seen when you hear [musicians] refer to the higher frequencies as bright and the deeper ones as dark or sometimes muddy. With paint, I try to describe the same kind of balance between shapes, colors, and values that exists between certain volumes, notes, and instruments in a well-produced piece of music.

BRIAN MAY

Brian May was born in Hampton, Middlesex, a few miles outside London. Always a top student, the young Brian was fascinated by astronomy—he graduated with honors in physics and mathematics from Imperial College in London—and would probably have become an astronomer if not for his love of music. May's father taught him to play the ukulele-banjo when he was a child and May later moved on to the piano. He ended up choosing to play the guitar, because he found it to be an expressive and flexible instrument.

Unable to find a guitar on the market that offered the qualities he wanted, the teenage May decided to build one with his father. They used a piece of 120-year-old mahogany (taken from a family mantelpiece) for the instrument's neck. The guitar boasted many original design features, some of which have since become almost standard in the industry.

In 1964 May formed his first band. Eventually, that band—with some additions—became **Queen**, one of rock music's most successful concert bands. During its twenty-year life span, the group sold more than 100 million records. Their hits included "We Are The Champions," "Killer Queen," "We Will Rock You," and "Another One Bites The Dust."

In 1991 band member **Freddie Mercury** died tragically of AIDS. A gigantic concert, with a host of international stars including **Elton John**, **George Michael**, **David Bowie**, and **Annie Lennox** honored his memory.

Since then Brian May has pursued a solo career, producing such albums as *Star Fleet Project* and *Back To The Light*. His newer work highlights his well-known guitar skills, while showcasing his talents as a vocalist, songwriter, and frontman.

Seville Guitar Legend, **woodcut**

The 'woodcut' is really a sticky paper print!

I always find excursions into visual art refreshing. While it's being created, my own music is something quite obsessive; it's always jostling my mind. Pictures let me out into a wider world. This one was done with my girls in California one summer.

JOHN MAYALL

John Mayall has always loved the blues. As a boy growing up in Manchester, England, he regularly raided his father's record collection. He was smitten by what he found there, particularly by the gutsy sounds of Albert Ammons and Big "Bill" Broonzy. By the time he was thirteen, Mayall was playing piano and guitar, inspired in part by his father, who played in local dance bands.

He initially pursued art as a career because "music was never considered a way of making a living." At the age of thirteen, he went to junior art school, and from there he went into window display work at a department store. Mayall was soon promoted to the drawing office and was regularly installing exhibitions around the store. His art career was interrupted by two years in the army. Upon his discharge, Mayall returned to England to resume his studies and to pursue music a bit more energetically.

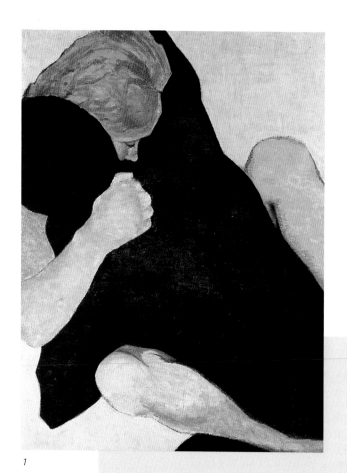

1

At first he played with a group called the **Powerhouse Four**, which later became the **Blues Syndicate**. Receiving encouragement from blues pioneer **Alexis Korner**, Mayall moved to London. Once there, the Blues Syndicate became the **Bluesbreakers** and went on to define the sound of British rhythm and blues.

Since 1963 John has recorded some thirty albums, changing his band line-up almost as many times. This keeps him, he says, from getting "stagnant as a performer." Over the years, Mayall has explored elements of jazz, gospel, and rock in his albums, from *Jazz=Blues Fusion* and *Last of the British Blues* to *Wake Up Call*.

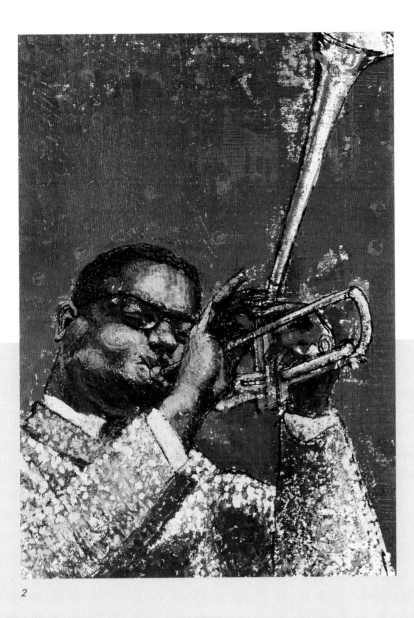

2

1. *Untitled,* gouache
2. *Dizzy Gillespie,* gouache
3. *I Guess These Things Are
 All Called Mother And Child,* wood
4. *Rodney Winfield,* felt pen

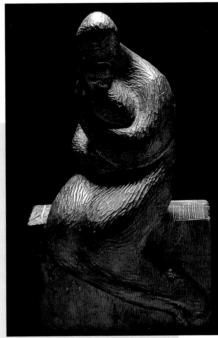

3

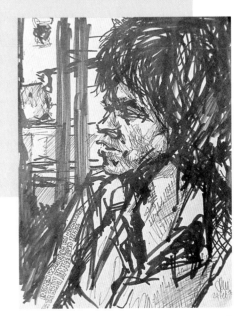

4

I was born with a love of music as well as a love of art, but I treat them as very different things. In art you are the total controller. With a visual thing, you see the creation bit by bit, and you have the chance to correct and to build it. When you play music, you have a gut reaction that hits you second to second, and you just play without even thinking. The only time art and music are similar is when you record in a studio. Then composing is like building a piece of art: you build the piece of music and play around with musical colors. The exciting thing about music is that I never know exactly where it is going; what I play next will depend on what I hear in my head or what somebody else is playing. I think that unpredictability and interchange of ideas is what I find most stimulating.

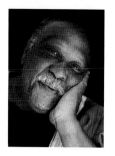

LES McCANN

A native of Lexington, Kentucky, Les McCann grew up in a music-loving household of four brothers and three sisters. His mother used to hum opera as she went about her chores, and his father was an avid jazz enthusiast.

Country and hillbilly music were strong influences in Kentucky, and the young McCann, like so many of his peers, grew up singing in the church choir and playing in the school marching band. McCann was introduced to more cosmopolitan forms of music by his band teacher, who took him to see concerts, the opera, and the ballet.

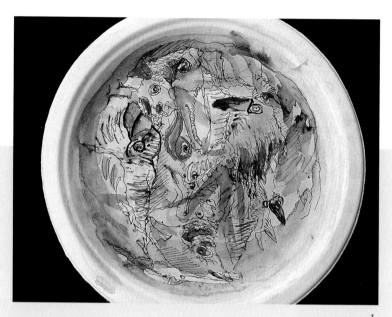

1

McCann's ticket out of Lexington was the U. S. Navy—which had some fine music schools. During his time in the navy, he learned by listening to people like Erroll Garner, whose original piano style impressed him.

After leaving the navy, McCann ended up in the Bay Area where he was exposed to the musical talents of Cal Tjader, Dave Brubeck, and others. It wasn't long before McCann was working as a doorman at the Blackhawk, a world-famous jazz club.

Soon McCann formed a trio and started recording a series of popular albums, including *Les McCann Plays the Truth* and *Swiss Movement.*

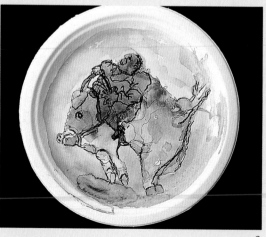

2

3

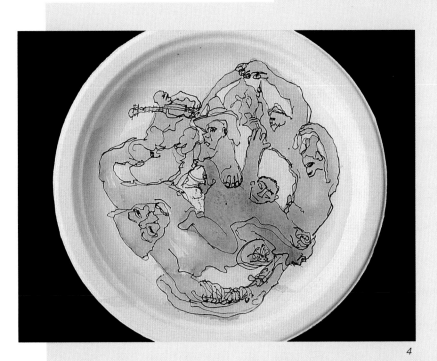

4

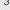 *I paint spontaneously. I love textures. I took an Air France flight to Paris and the mats they served the food on were so beautiful that I asked for some. They gave me a whole stack, about five hundred of them, and I used them to draw on.*

I came home from a European tour. It was the holidays and I noticed the textures of the paper plates. They were just sitting there so I decided to use them. This is never something I plan. It just happens. I like ink and watercolor and wash.

For me, art is the further exploration of one's self. Going into those levels that are not conscious. Art can happen in those quiet moments when you're deeply into something. For me, art is the challenge to get to know myself even better. It's a beautiful trip to go on. "

1. *Untitled*, ink and wash on paper plate
2. *Untitled*, ink and wash on paper plate
3. *Untitled*, ink and wash on paper plate
4. *Untitled*, ink and wash on paper plate
5. *Untitled*, ink and wash on paper plate

5

ROGER McGUINN

James (Roger) Joseph McGuinn was born in Chicago. He studied at the Old Town School of Folk Music and was a folk singing fixture in Chicago before he took his talents to Manhattan. In New York he worked as back-up to the **Limeliters**, **Bobby Darin**, and others, eventually signing on as **Judy Collins's** musical director. Later, he formed a group called the **Jet Set,** which metamorphosed into the **Beefeaters** and then the **Byrds**.

The Byrds burst onto the charts with "Mr. Tambourine Man," the first of many Bob Dylan songs they would record. During the subsequent five years they released seven incredibly successful albums, including the futuristic Fifth Dimension and the Nashville-produced Sweetheart of the Rodeo.

In the early seventies, after the band broke up, McGuinn struck out on his own and produced a series of records before joining **Dylan's** legendary touring troupe, **Rolling Thunder Revue**. For Dylan, McGuinn played the 12-string acoustic guitar and later his trademark 12-string Rickenbacker guitar.

Roger McGuinn was inducted into the Rock & Roll Hall of Fame with the other members of the Byrds in 1991. He continues to perform songs like "Back From Rio," "King Of The Hill," and "Eight Miles High" to audiences around the world.

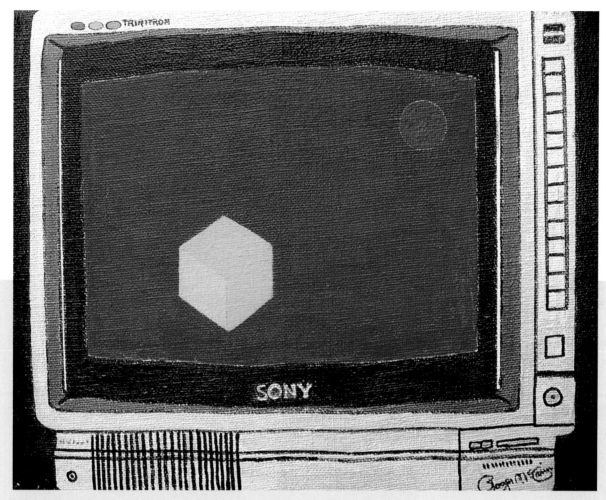

TV–2, acrylic on canvas

I got the idea for the image in 'TV2' in Greenwich Village during the winter of 1963. I saw gray skies and bare trees from my window overlooking Washington Square Park, and I craved color. I imagined the cube and the red sphere floating in deep space.

Years later, when I needed some color in my Los Angeles high-rise condominium, I remembered the cube and sphere and painted a ten-by-fifteen foot mural on my living room wall.

The electro-luminescent colors reminded me of a television picture, and I decided to do the painting 'TV1' using a Sony Trinitron as a theme. I gave it to Tom Mayberry, who didn't own a television set, as a birthday present. My wife liked the painting so much that I painted 'TV2' for her. She later donated it to the KLSX Classic Rock Art Show to benefit AMFAR. She was hoping to buy it back, but someone outbid her.

JOHN MELLENCAMP

John Mellencamp was born in 1951 in the small town of Seymour, Indiana. He has stayed near his hometown, but has traveled considerable artistic distance since his boyhood.

Mellencamp was the second child in a family of three boys and two girls. His forebears were farmers and peasants; his father was an electrical engineer. Mellencamp started making records in 1976. Since that time he has produced fourteen records, which have sold over thirty million copies. These fourteen records also produced forty top-twenty singles. John is one of only three artists who have had a number one record concurrently with two singles in the top ten. The other two artists are Michael Jackson and John Lennon.

His most recent album, *Dance Naked,* is a mix of all the ingredients—the American spirit of forbearance and the sly humor—that make Mellencamp's music such a success.

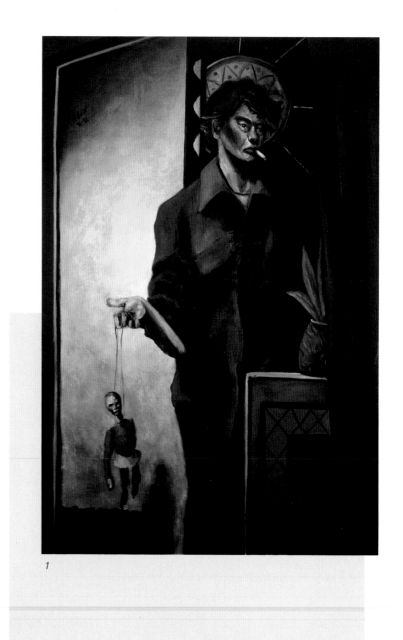

1

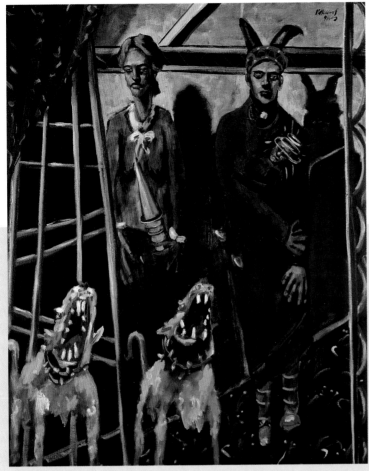

2

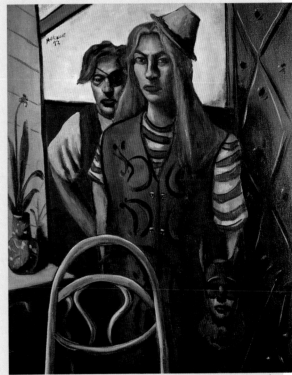

3

1. *John With Puppet,* oil on canvas
2. *Gates of Hell,* oil on canvas
3. *Party Goers,* oil on canvas

Art is a lifelong commitment. Something I can do in my old age. It makes life bearable.

NICK MENZA

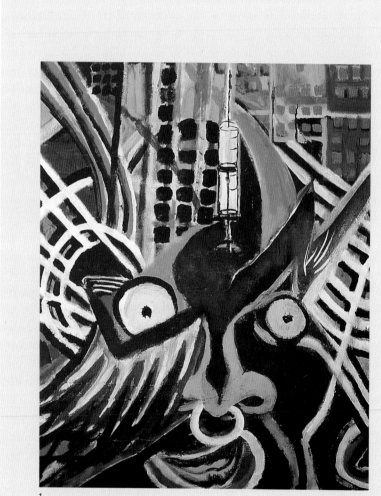

1

Nick Menza's boyhood began in Munich, Germany, but he was raised in California's San Fernando Valley. He grew up surrounded by music. His father was a noted tenor saxophone player with the Maynard Ferguson, Stan Kenton, and Buddy Rich Orchestras, so Nick was used to watching rehearsals and traveling with his father. By the age of five, Nick had already developed an interest in the drums, and by the time he was a teenager, he'd decided to be a professional drummer.

Foregoing the opportunity to attend college, Nick chose to play with several area groups, finally ending up as the drummer for **Megadeth**. His drumming can be heard on recordings of "No More Mister Nice Guy," a remake of the Alice Cooper hit, and "Rust In Peace." He has done several songs for movie soundtracks, including "Go To Hell" for *Bill and Ted's Bogus Movie*, "Angry Again" for *The Last Action Hero*, and "Ninety-Nine Ways To Die" for the *Beavis and Butthead* movie.

1. *Needle Man*, acrylic
2. *Huh!*, acrylic
3. *Alien*, acrylic
4. *War of the Worlds*, mixed media

❝ I was always into painting. I studied sculpture, graphic arts, oils, and acrylics. I found that painting was a release for a lot of the inner frustration that I couldn't get out on the drums.

I just paint whatever. I never say, "Okay, I'm going to paint a house now." I just start working with it and see what comes out and go with it. It's very ad lib, free-form, abstract. I don't even have a favorite artist. I like so many.

3

2

I probably paint ten different paintings on the same canvas before I finally come up with one I like. My family and friends come by and say, "Where's that painting you had yesterday?" I tell them I've painted over it, and they get all pissed off. "But I liked that one," they say. But I didn't. I'm the artist and I have to like it.

I think in the next twenty years the only sane people on the planet are going to be artists. Everyone else is too caught up in the system. ❞

4

JOHNETTE NAPOLITANO

Johnette Napolitano was born in Hollywood, California, in the late fifties. Early on, her parents were struck by her unusual interest in music and art. She began to play the piano at age eight, and when her elementary school teachers noticed her proficiency in drawing and in modeling clay, they recommended her for a gifted children's program at UCLA. Napolitano also attended a similar program at the Los Angeles County Museum of Art.

After high school, she decided to pursue a career as a fashion designer. She enrolled in junior college, but quit after a week, because she felt the school was overcrowded, needlessly competitive, and creatively limiting. It was then that she decided to explore the world of music.

Napolitano's band, **Concrete Blonde**, was signed to IRS Records in 1985 and released four albums to considerable acclaim soon after. The third of these albums, *Bloodletting*, was dedicated to her good friend artist Ron Scarselli, who, before dying of AIDS, encouraged Johnette to return to her art.

Since *Bloodletting's* release, Concrete Blonde has worked closely with LIFEBEAT, a national organization of musicians promoting AIDS awareness. Johnette observes that people "like to pretend AIDS never happened to anyone, will never happen to anyone, and certainly will never happen to them." Johnette devotes equal time to music, art, and AIDS awareness efforts.

Spirit of Mexico, acrylic and gold leaf on canvas

◦ ◦ *My primary inspirations are:*

—Ron [Scarselli]. The last year of his life he would paint furiously, surrounded by eight or ten canvases. He knew time was not to be wasted, and I learned profoundly from that.

—Mexico. I have been many places in the world and find what I miss most about L.A. is Mexico: the art, music, and food. We owe a great debt to Mexican culture. The art there is the art of the people and that moves me the most.

—the catacombs of Paris. The catacombs are miles of underground cave-tunnels. There, under the city and piled high on either side of the tunnels, are an infinite number of skeletons and skulls. They go as far as you

can see, in intricate designs and patterns. This will stick with me forever: our sexlessness, racelessness, and ultimate equality. The catacombs are a portrait of all of us, very much together, very much as equals. It is religious and final. It seems the catacombs are quietly waiting for us to finish with our precious little time here, waiting for us to finish debating those "differences" in each other that, in the end, will never have been there at all.

GRAHAM NASH

Graham Nash was born in Blackpool, Lancashire, England, during World War II. Two weeks after he was born, he moved with his mother back to Manchester, where he was raised. "A lot of my early images," says Nash, "are of blackouts, air raid sirens, bombings, and the like."

Although Nash's parents were not musically inclined, he remembers fondly how supportive they were of his interest in rock-and-roll. "They bought me," he says, "my first guitar at thirteen; they used to drive me to the clubs. I guess they were living vicariously through me in this one respect."

When he was five, Nash made a lasting friendship with a fellow student named **Allen Clarke**. They sang together at school assemblies and were performing regularly with one another by the time they were nine. In those early days, before he had a real guitar, Nash made an instrument out of plywood and practiced his moves in front of a mirror, lip-synching Frankie Laine and Johnnie Ray, and rock-and-rollers Little Richard, Buddy Holly, Elvis, and Fats Domino.

When Nash left home at the age of sixteen, Clarke and he formed the **Deltas**. The Deltas soon become the **Hollies,** who gained fast popularity, rapidly becoming Manchester's top group. They signed a recording contract and rose high on the charts.

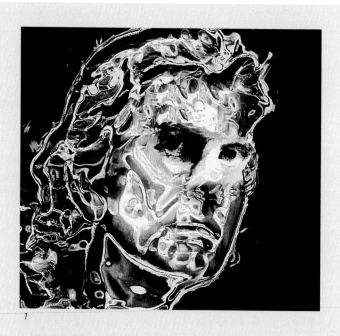

1

Despite their success, Nash eventually became disenchanted with the pop-based work he was doing with the Hollies. One night in Los Angeles he met **David Crosby,** who introduced him to **Stephen Stills**, and Nash's life and work took off in a new direction.

From the start **Crosby, Stills and Nash** (joined by **Neil Young** in 1970) created an unmistakable sound, one that has been indelibly impressed on the collective musical consciousness. Over the years Nash has composed such classics as "Marrakesh Express," "Cathedral," and "Just A Song Before You Go."

In addition to being a musician, Nash is actively involved in the anti-nuclear movement and other efforts to protect the environment.

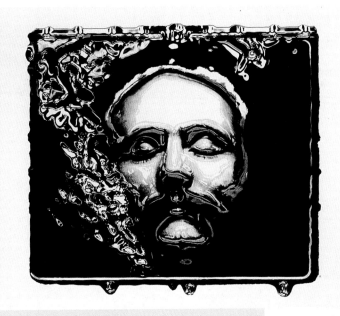

66 *Sculpting is my latest passion. It's a process of addition by subtraction, creation from destruction. You're destroying the stone to create something else. I do it as a mental exercise, mainly.*

There's a lot more going on with creative artists than what appears on the surface. To a lot of people I'm only a musician. But to a lot of other people, music is a secondary part of my life. In the art world, people are curious about my music career, but it's not what I'm known for . . . which makes me very optimistic about the future. I'm not about to be placed into any 'old' category, because that's not who I am. **99**

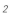

2

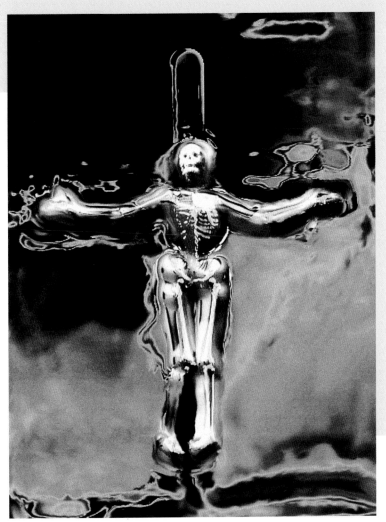

1. *Self Portrait*, digital ink-jet print
2. *Chrome Magnum*, digital ink-jet print
3. *To Be Remembered*, digital ink-jet print

3

KIM O'DONNELL

1

Born on June 18, 1964, in Portsmouth, Virginia, Kim started drawing at age seven. Mother Carol O'Donnell and Aunt Melanie Jones Fisher immediately noticed that she drew well, even at such a young age. Their encouragement and art supplies kept her interested. A love for music and a desire to learn every instrument led Kim to get her first drum set at age thirteen.

In 1985, while attending Buffalo State college in Buffalo, New York, she met **Green Jellÿ** (formerly **Green Jellö**) member **Bill Manspeaker** and played a few shows with the band at the Continental club. Kim and Bill moved to Los Angeles in 1987 to get warm and with hopes of getting a better job. Green Jellÿ made their television debut with a performance on "The Gong Show" in 1988, and Kim became a full-time band member.

Green Jellÿ is a character-based group, performing in full-body costumes. As a member of the band, Kim takes on her alter ego, Sadistica. She designs all of the band's album and video art, T-shirts, posters, and characters. In 1993 Green Jellÿ scored big with their debut album, racking up gold album and video awards for *Cereal Killer,* and a gold single for the song "Three Little Pigs." Their success translated internationally with several more gold and platinum awards. Through a joint venture with Zoo Entertainment/BMG, Green Jellÿ has formed its own production company run by leader Bill Manspeaker. Kim is the company's art director and uses a computer for her graphics and 2D and 3D animation. In addition to her art, Kim sings on a few songs on Green Jellÿ's second album and video, *333.*

When asked who or what has influenced her art, Kim's response is "television." She is, however, inspired by and enjoys the work of artists Aubrey Beardsley, Salvador Dalí, Joe Coleman, and Robert Williams. Kim particularly likes Williams's work because, she says, "he draws like me" —a style that used to frustrate Kim's high school art teachers to no end.

2

3

4

I like doing my art because I enjoy getting a reaction out of people. It's also very relaxing and a great mental release.

1. *The Whistlers*, acrylic
2. *Frost*, spray paint
3. *Peeping Tom*, acrylic
4. *Kim's Happy New Year*, mixed media

YOKO ONO

1. *Endangered Species*, mixed media bronze
2. *Painting to Hammer a Nail*, bronze
3. *Apple*, patinated bronze
4. *Play It By Trust*, white-patinated bronze
5. *Painting to Hammer a Nail*, mixed media

1

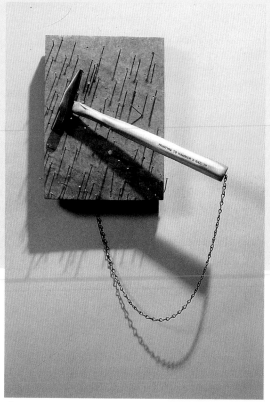

2

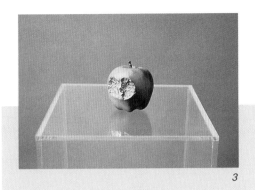

3

4

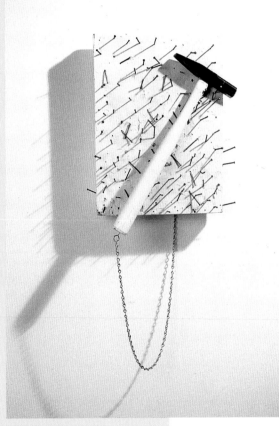

5

I never thought this would happen, and I feel very lucky to be getting a second life out of my artwork. Although most people think I suspended my activities as an artist for several years, I never stopped making work. My work just took a different form for a while. Handling the legacy of my marriage was an artwork of sorts.

I consider 'Strawberry Fields,' a site-specific sculpture, to be one of my best works. As far as the art world is concerned, sometimes that circuit is open and sometimes it's closed. Though it was closed to me for many years, I didn't stop being an artist.

I found the classical art training I'd been given stifling. I thought art needed something more, and conceptual art was wide open as far as what was allowed. Then I met John Cage and he taught me that it's all right to do anything. His work was like seeing a big green light that said, 'Go!'

I grew up in a time when the creative needs of women were basically ignored, but from the word go, I knew what I was doing when it came to art. I think that had a lot to do with the fact that I was shy and art allowed me to communicate in a way that didn't require so much courage.

LEE OSKAR

A founding member and lead harmonica player for the pioneer funk/jazz group **War**, Lee Oskar is known for his harp solos, which add dashes of color to War's music—a combination of rhythm and blues, jazz, and rock with Latin influences.

Oskar was born in Copenhagen, Denmark. He received a harmonica as a gift when he was six years old. In those days, the going fad was the yo-yo, but Oskar stuck with his harmonica. He grew up listening to Danish radio, listening to all types of music, but he cites Ray Charles as a particular influence.

Oskar moved to the United States when he was eighteen, arriving with little more than the harmonica in his pocket. After brief stops in other cities, he arrived in Los Angeles where he joined forces with **Eric Burdon**, who had recently disbanded the **Animals** and was looking for new collaborators. They added **Charles Miller's** saxophone to form a horn section and War was complete.

Between War tours, Oskar has had a career as a solo artist and has run a successful harmonica company. Of War he has said, "When performing, we all make it happen synergistically, as a group. I'm the one who gets to dance around with my notes and paint with music. It's a wonderful situation and it's always exciting."

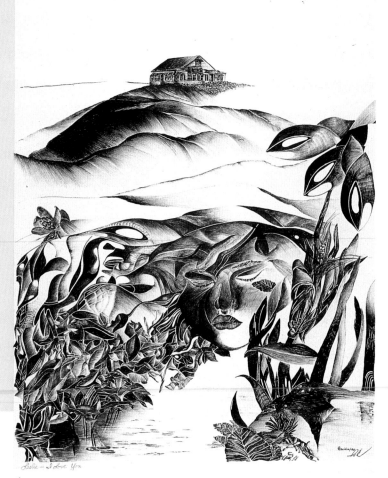

1

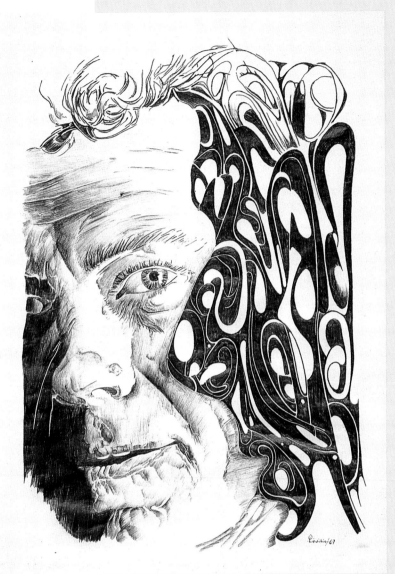

2

1. *Leslie I Love You*, ballpoint pen
2. *Their Profile*, ballpoint pen
3. *Maybe Someday*, ballpoint pen

I visualize a picture and get compulsive with shading and form. The final drawing usually ends up being totally different from my original concept . . . it grows out of the moment and just happens. Drawing is another side of me. There are things I express in music that I can't express in my art and vice versa. Down the road, I'd like to spend more time combining the visual and the audio.

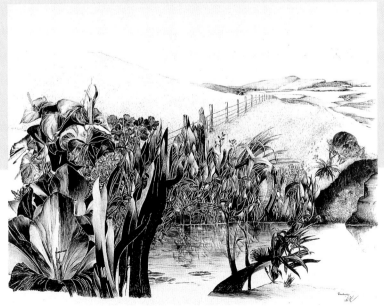

3

IGGY POP

O.K. I'm Iggy Pop and this is my life. I got born in Michigan in 1947. Mom and Dad: hard working and straight. Schoolteacher and executive secretary. Lived at Coachville Gardens Mobile Home Court, Ypsilanti, Michigan. At age five, I played the drums with my Lincoln Logs and Tinkertoys. At age eight, I heard Sinatra and wanted to sing. Smart in school but not good at homework. Most likely to succeed, 9th grade, 10th grade. Then in 1962 I formed the **Iguanas***, high school rock band. We cut a single our senior year and then a few summers later we got a gig in northern Michigan at the Ponytail Club. Wow, professional employment, far away from home. Lots of forty-five minute sets, five minute breaks. Six nights a week. A bare room with cold running water, five mattresses and one electric light. Pay— fifty bucks a week.*

Then I started getting wild. Grew my hair to my shoulders and dyed it platinum; got arrested and had my first mug shot taken. Got fired from the Ponytail.

Dropped out of the University of Michigan and went with a blues band called **Prime Movers***, played bars in Detroit and Chicago. Then I found two high school dropouts on a street corner and started the* **Stooges***. Totally did our own thing like nobody else. Three great albums. Went nuts from the life, got screwed in the business and went to L.A. I went underground, was arrested a few more times and then resurfaced in '76 with my first solo album, recorded by* **David Bowie***. Lived in Europe for two years with Bowie, did two albums, both great. One live recording only so-so.*

Did a lot more albums, fifteen in all, half great, half so-so, ups, downs, N.Y.C., London. Now I have a place in Mexico for when I can't stand it anymore. I love my garden, my wife, my dog and cat, but I also love noise, aggravation, girls, regular guys, music. I drink beer and wine sometimes, hate publicity whores, hokey music, people who wanna use me, and conceited dicks. My ambition is to make better music, live my life in peace, and then die.

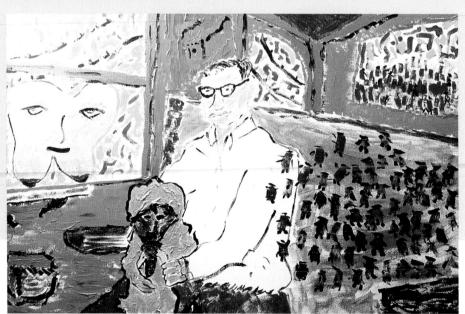

1

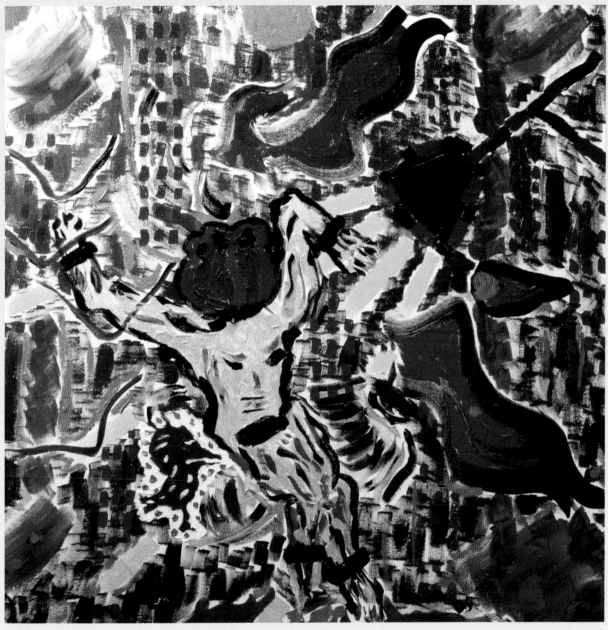

2

1. *Dad on a Train,* acrylic on canvas
2. *Self Portrait with Bird,* acrylic on canvas

JEFF PORCARO

Jeff Porcaro was born and grew up in Hartford, Connecticut, in a musical household. His father was Joe Porcaro, a prominent percussionist and a fixture with some of the great swing and jazz bands. Inspired by his father, the young Porcaro took up the drums at the age of five. He immediately demonstrated rhythmic talent.

Throughout grade school, Porcaro continued to grow as a musician, and in high school he formed a group called **Still Life**. Porcaro left high school early to become a professional drummer. For several years, he traveled on the road with **Sonny and Cher** and **Steely Dan**. As a result of this touring, he had learned the ropes and developed his own sense of style before he struck out on his own with **David Paich**, son of the noted arranger/conductor/composer **Marty Paich**. Porcaro's father and Marty were friends, so it seemed natural that their sons would get together. In 1978 Jeff and David formed the rock group **Toto**.

From an early age, Porcaro was also very interested in painting and drawing. He designed some of his own album covers and drew and doodled constantly. He was fond of painting soldiers and scenes pertaining to the Civil War era.

Jeff Porcaro dedicated himself to his family and the arts until his untimely death in 1992. One of the legacies he left his three children was his love of art—in fact, his seven-year-old son, Miles, recently won an art competition for elementary and high school students.

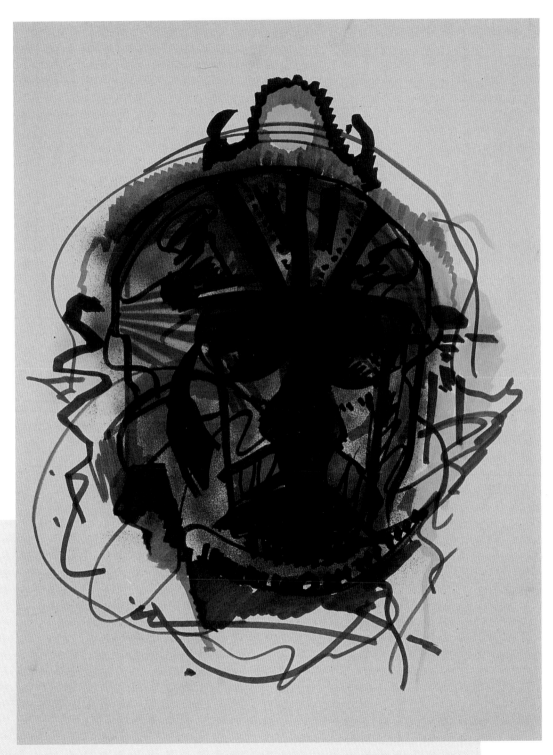

Skull, felt tip marker

"Jeff loved all kinds of art. Even though he was a wonderfully gifted drummer and musician, I feel that he would have been quite content to only paint and express himself in that way. He looked forward to those quiet times when he had nothing else to do but paint."

—Susan Porcaro

CARLY SIMON

Carly Simon comes from a large, musically adept brood. One of her sisters, Joanna, is a well-known opera singer; another, Lucy, has written a pair of Grammy-winning children's albums and the music for the Broadway musical *The Secret Garden*. While enrolled at Sarah Lawrence, Carly and Lucy formed a folk duo, the **Simon Sisters**, which had an early hit with "Winken, Blinken, and Nod." But Carly's earliest musical memory is that of her ukulele-playing uncle, Pete "Snakehips" Dean, who taught her to play when she was only five.

After going solo in the seventies, Carly cut a string of influential and innovative hits starting with "That's The Way I Always Heard It Should Be," which won her a Grammy Award for Best New Artist in 1971. Famous tunes followed, including "Anticipation," "You're So Vain," "Mockingbird," "Haven't Got Time For The Pain," and "Jesse." By the middle of the decade, Simon was firmly established as one of the premier recording artists of her time. Even the legendary Fred Astaire chose to record his own version of "Attitude Dancing," one of her hits.

In the eighties and nineties, Carly Simon moved successfully into the writing of songs for motion pictures. Some of her more famous numbers include "Nobody Does It Better" from *The Spy Who Loved Me*, "Coming Around Again" from *Heartburn*, and the rousing "Let The River Run" from *Working Girl*. (The latter song won her Oscar, Golden Globe, and Grammy Awards). Simon has also done songs for *Postcards From The Edge*, *Desperately Seeking Susan*, and *Nothing In Common*. Simon scored, wrote, and performed all the music for Nora Ephron's *This Is My Life*, a film about a working mother in the nineties. Herself the mother of two, she knew only too well the challenges that movie depicted.

Simon continues to stretch into other creative realms and wrote, a one-act opera for young audiences, *Romulus Hunt*, which had been commissioned jointly by the Metropolitan Opera and the Kennedy Center. It premiered in New York City in February, 1992.

I have just started painting. I can paint sailboats and certain kinds of clouds. I tried to copy a Renoir. There is very little original about it; even the fact that it's quite bad isn't original. Still, I'm only a beginner. We all begin as copiers. I started out singing just like Odetta and finally developed my own voice. Maybe in another twenty years I will truly be able to sign my own painting.

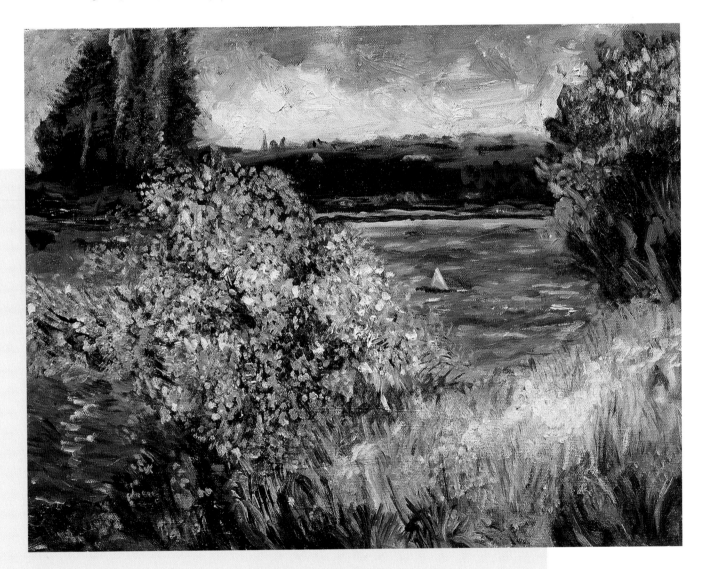

Starting at the Beginning: Landscape with Sailboat, oil

FLOYD SNEED

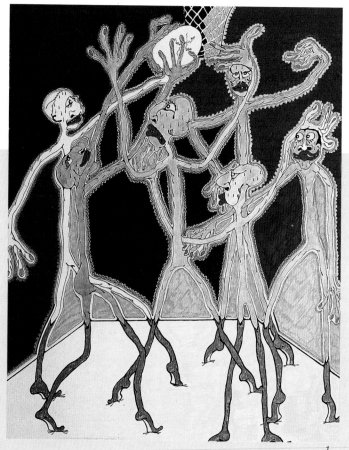

Floyd Sneed was born and raised in Calgary, Alberta, in a musical household; his father played guitar, his mother sang in church, and his brother and sister played keyboards. Sneed took up the drums, and they played together as the **Heat Wave** throughout Sneed's childhood.

Once he'd decided to pursue music seriously, Sneed moved to Vancouver and hooked up with **Tommy Chong** (of **Cheech and Chong** fame). Chong was then Sneed's brother-in-law, and the two played together for several years before Sneed decided to move to Los Angeles to sign on as the original drummer for the group **Three Dog Night**.

Sneed worked happily with Three Dog Night for fifteen years. When they disbanded, Sneed re-formed Three Dog Night's rhythm section into the group **S.S. Fools**. Members of that band played together successfully for several years before going their separate ways.

Sneed continues to divide his time between his music and his painting.

1. *The Basketball Players,* pen and colored marker
2. *Third World Builder,* pen and colored marker
3. *The Audience,* pen and colored marker

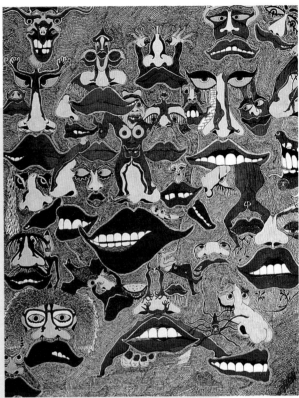

> *I was always a sketcher . . . especially in the recording studios.*
>
> *My art has finally found a direction which I call 'Surreal Humor Art.' Basically, it's cubism with round corners.*
>
> *I like to use pen-and-ink, colored markers, and pencils.*

2

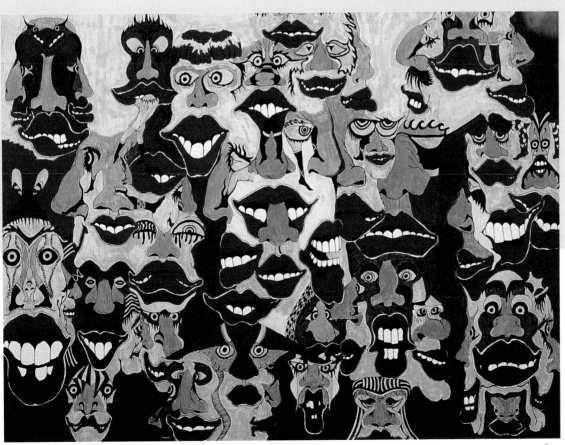

3

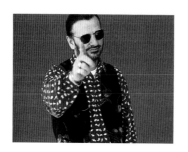

RINGO STARR

Since his debut with the **Beatles** in the sixties, Ringo Starr has endeavored to find his own place in the world of music. In doing so, he has, perhaps, taken to heart the lyrics of one of his recent songs: "It all comes down to who you crucify. You either kiss the future or the past good-bye."

Starr has successfully carved out a name for himself as a solo act by recording ten solo albums since 1970. His hits include "Photograph," "It Don't Come Easy," "Oh, My, My," and "You're Sixteen."

Starr has performed as an actor in more than a dozen films, and he generously supports the work of his colleagues by offering them guest spots and cameos on his recordings and videos.

In 1992 **Ringo Starr and the All-Starr Band** completed a world tour performing many of the songs from *Time Takes Time*. It was the first time Starr had ever done a solo swing through Europe.

Painting is my madness.

Untitled, acrylic

DONNA SUMMER

Born Donna Adrian Gaines in Boston on December 31, 1948, Summer began singing as a soloist in the church choir at the age of ten, and ended up as the undisputed Queen of Disco.

1

Summer's career began when she made her way to New York City, where she auditioned for the Broadway production of *Hair!*—only to be offered a role in the Munich, Germany, production instead. In Europe more opportunities presented themselves and soon Summer was in the companies of *Porgy and Bess* and *Showboat,* and was a featured vocalist in *Godspell* and *The Me That Nobody Knows.*

Summer recorded albums under a Munich label but didn't get attention in the United States until her song "Love to Love You Baby" was released. Written by Summer and her producers Giorgio Moroder and Pete Bellotte, the song became an international smash, with both single and album earning gold certifications.

In 1978 Summer became the first female vocalist to score a number one single and album on the Billboard charts simultaneously with her moving rendition of Jimmy Webb's "MacArthur Park," and her album *Live & More.* She broke her own record by achieving this feat again less than six months later with the platinum single "Hot Stuff" and the multi-platinum album *Bad Girls.*

This phenomenal success was followed by a string of number one gold singles and multi-platinum albums including *The Wanderer, On the Radio—The Greatest Hits Vols. 1 & 2, She Works Hard for the Money*, and *This Time I Know it's for Real,* sell-out concerts worldwide, four Grammy Awards, six American Music Awards, and her star on the Hollywood Walk Of Fame. A long-awaited Christmas album is set for release in the fall of 1994.

" *People who know me have known about my interest in art all along. It's always been my hobby, my relaxation thing. My style is very expressionistic, allowing me to communicate without bounds.*

Not having gone to school, I don't get caught up in the rules. The result is often abstract; in my pictures, a person's skin may be blue.

With my painting, I am able to be myself without making any compromises. I have this need to paint because it makes me peaceful. "

3

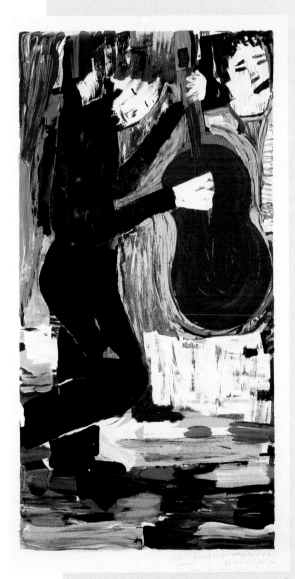

2

1. *Driven by the Music,* bronze
2. *Jazzman,* acrylic on canvas
3. *Driven By the Music,* lithograph

DWIGHT TWILLEY

Dwight Twilley is a writer and rock music artist of international renown. Best known for his hits "I'm on Fire" and "Girls," he has released numerous albums on the Shelter, Arista, EMI, and DCC record labels.

A native of Tulsa, Oklahoma, Dwight began painting and writing poetry at a young age. His musical career began at age fifteen, when he found his brother's abandoned guitar in a closet: Dwight was enthralled to find that his words and images could take on new meaning by being fused with melodies.

In the early seventies Dwight met drummer and singer **Phil Seymour**, and together they formed the **Dwight Twilley Band**. The first song they recorded, "I'm On Fire," was an instant smash. The band's first album, *Sincerely*, was named Debut Album of the Year by *Rolling Stone* magazine in 1976.

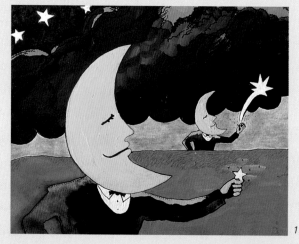

1

Twilley has remained a prolific tunesmith with songs like "Twilley Don't Mind," "Somebody to Love," and "Why You Wanna Break My Heart?" In addition to his worldwide touring, Dwight performed at the 1984 summer Olympics and played for the troops of Desert Storm on the aircraft carrier USS Ranger in 1991. He has been a presenter at the American Music Awards, and had his own hour-long special on MTV. His music has been featured in such films as *Wayne's World*, *Ladybugs*, *Up the Academy*, and *Worth Winning*.

Dwight has never lost his interest in the visual arts, and 135 of his original works were exhibited in a one-man show at the Museum of Rock Art in Los Angeles in 1982. His artistic and literary endeavors came full circle in his unique parenting book *Questions from Dad: A Very Cool Way to Communicate with Kids*. (1994).

2

The fact that I've never considered myself a professional artist has always allowed me to do whatever I want and say 'who cares what anybody thinks about it!' My work has only been exhibited once and I have never tried or wanted to sell it.

However, in recent years my art has assumed a new and more meaningful purpose. I've use it as a means of communication with my daughter, Dionne, from whom I'm separated by a great distance. I illustrate 'Dad's Tests' and have her respond to my questions. I realize that, with so much of my art displayed in my book Questions from Dad, *my work may now fall under more critical eyes. But hey, Twilley don't mind. If Dionne gets a kick out of my Moonheads, cats, and dogs, that's all that matters to me!*

3

1. *Skylighters,* acrylic
2. *Out In the Rain,* watercolor
3. *Clockwork,* mixed media
4. *Digital World,* watercolor

4

RICKY VAN SHELTON

Ricky Van Shelton's career has taken him from the back roads of Grit, Virginia, to worldwide recognition as a major country star. Like many other teenagers, Van Shelton grew up listening to the Beatles and the Rolling Stones. Unlike many other teenagers, he became a performer at the age of fourteen when his brother coerced him into playing guitar in his country band.

In 1986 a record company vice-president heard him perform, and two weeks later Van Shelton was cutting his first album, *Wild-Eyed Dream*. The album went to the top of the charts and had five country hits on it before it went platinum. Van Shelton was recognized with a number of the music industry's newcomer awards.

Since then, Ricky has been turning out albums and making personal appearances. He appeals to audiences everywhere with his down-to-earth manner and genuine humility.

Van Shelton is also the author of the children's book *Tales of a Duck Named Quacker*. It's moral message reflects Shelton's personal values. Van Shelton's music has been expressing these values more and more strongly, moving in the direction of inspirational music. He explains the shift by saying, "I believe in it and my fans believe in me. Bluegrass, country, gospel—you'll hear all my roots in the melodies and the story lines. It's something I feel I have to do for the fans. If not, I might as well go back to pipefitting."

1

2

3

66 *When I was about five years old, I told my mama I wanted to sing and draw pictures. I never changed my mind, and I never stopped believing that I would be able to do both.*

Beauty is in the eye of the beholder. A picture is just a picture until you frame it . . . and then it's art.

And for all those who love painting: never be influenced by the opinion of art critics for their opinion lasts only as long as their paycheck. 99

1. *A Soldier Sees the South Pacific #1,* watercolor
2. *A Soldier Sees the South Pacific #2,* watercolor
3. *Childhood Memories,* oil

RICK VITO

Rick Vito's earliest musical influences were Elvis and the artists of Dick Clark's "American Bandstand." He got serious about the guitar in his teens and first appeared on stage as the lone guitarist in a doo-wop group, which he has described as "five guys in leather jackets, with slick hair and Cuban heels." Before long Vito was interested in blues and rockabilly and was studying B.B. King, Chuck Berry, and others. While in college, Vito made friends with the rock duo **Delaney and Bonnie,** who suggested that he go to Los Angeles; Vito took their advice and within a short time was playing lead guitar for **Delaney.**

Since then, Vito has played for **Little Richard, John Mayall, Bonnie Raitt,** and **Jackson Browne,** and has written songs for **James Cotton, Maria Muldaur,** and **Roger McGuinn.**

Vito's big break came when he was asked to join **Fleetwood Mac.** He traveled with that group's highly successful *Tango In The Night* tour, which turned into a full-length concert tour video. On it, Rick's powerful presence is clear.

After the tour Fleetwood Mac cut additional tracks for their *Greatest Hits: Fleetwood Mac* album and for *Behind the Mask.* Vito contributed and sang lead for four original songs on *Behind the Mask.* In doing so, Vito caught the attention of a record company president who signed him to a contract that led to the critically acclaimed album *King of Hearts.*

Vito continues to perform and record with his three-piece band, the **Mondo Rhythm Kings.** They turn out the earthy mix of blues and rock for which Vito is known.

1

2

3

My main influences center around abstract expressionism, especially what is commonly referred to as Art Deco. Most everything I create incorporates a musical theme of some sort or another. Music has always been my chief inspiration regardless of the medium. It could be the sound or the form of a guitar, the rhythm of a dance, or the excitement of hearing a song, a recording, or a great blues singer (like Howling Wolf) that makes me to want to express that exhilaration in some way. For me it all seems connected.

My interest in designing guitars probably goes back to grade or high school. My textbooks were filled with drawings of wild guitars. After I became a professional musician and earned enough to buy all the vintage Fenders and Gibsons that I wanted, I started experimenting with some original ideas.

I came up with a few models that combined my interest in the Streamline Moderne period of the thirties and forties with my love of the guitar. What resulted were the 'Deco Streamliner' and the 'Deco Skyliner,' both of which I've been granted design patents on. Eventually I could see them and others I've come up with produced commercially. But for now they will remain my personal pieces. They feel like my children.

1. *Deco Skyliner,* wood, chrome, laquer (U.S. design patent #336,100)
2. *Deco Streamliner,* wood, chrome, laquer (U.S. design patent #310,842)
3. *The Wolf,* mixed media

ROGER WATERS

Roger Waters is not your average rock star. He shies away from the limelight and has a strong independent spirit that often sets him against the grain. And yet, the albums of **Pink Floyd**, under Waters's leadership, have sold more than 55 million copies.

George Roger Waters was born in Cambridgeshire, England. As a child he enrolled in an art class that **Syd Barrett** also attended. The two were later to form Pink Floyd. Roger went on to study architecture but remained interested in pursuing a career in music, so, along with some fellow art students, he formed a band that was called **Sigma 6**, then the **Meggadeaths** and finally the **Screaming Abdabs**. Once Syd Barrett was brought into the group, the name was changed again to Pink Floyd (after two of Syd's guitar heroes, Pink Anderson and Floyd Council).

Pink Floyd soon became the house band for London's underground movement, and it wasn't long before they'd recorded their first single "Arnold Layne." The group went on to produce extremely successful albums including *Dark Side of the Moon* and *The Wall*. They also scored music for films like *The Committee* and *Zabriskie Point*. Guided by Roger, the band's appearances grew increasingly lavish and theatrical. One concert used over nine tons of equipment.

Waters's solo career began the year after Pink Floyd released their appropriately titled *The Final Cut* album. Waters's album *The Pros and Cons of Hitchhiking* was followed by a highly successful world tour.

1

1. *Filoctetes*, charcoal pencil
2. *The Kalamos Chair*, pencil
3. *Stuart the Spaniel*, bronze
4. *Seamus O'Connell*, conté crayon

2

Strangely enough, I very rarely paint. I don't even draw very much, but I do enjoy sketching animals. Still, I always have a sketch pad and some pencils around just in case the mood strikes me.

I don't know what prompts me to want to do it. I suddenly look at something and just say I'd like to draw that. But I don't always do it immediately; I've had an idea for a painting in my mind for the last year. I wait for the absolute right time. There's something about the concentration involved, about how hard you have to look at something in order to capture something of its spirit that I find very compelling.

4

3

PETER WESTHEIMER

1

Australian-born Peter Westheimer combines many types of music—classical, ethnic, rock, and reggae—in his record albums and film scores. Perhaps the diversity is a result of Westheimer's eclectic musical education—he has studied the violin, Indian sitar, flute, clarinet, synthesizer, and electric guitar. Between his studies, he has worked as an actor, utilizing his instrumental skills in community theater. He has also practiced medicine and spent lengthy periods of time in Central Java, studying tai chi and Eastern religions.

In the last twelve years, Westheimer has used electronic instruments to create a warm blend of sound for his original compositions. From his studio in Sydney, he has released two record albums, three video clips, and an instrumental CD/cassette album entitled *Transition*. He has also composed music for Australian documentaries, feature and corporate films, and multi-media art exhibitions.

2

3

Music is my primary artistic medium; however, I really enjoy and need to work with other creative modalities, including paint.

The process of composing a piece of music or painting a picture is something magic and intangible. Both consist of layers of juxtaposed, improvised, or crafted ideas. These are then shaped to varying extents.

Painting a picture for each piece of music on my CD album Transitions *allowed me to visually reenter and reinterpret my original musical impulses in a relaxed and playful way, without the expectations or preciousness that I tend to associate with making music.*

My travels in Indonesia and India (countries with a unique and inspiring culture) and my life in Australia (a country with aboriginal roots and an unusual landscape) continue to have a major influence on my work.

My involvement in the planning, editing, and production of film clips for my music and my work on multi-media exhibitions have been further explorations into the visual arts. Since it is a time when telecommunications and the creative media are changing rapidly, I try to keep open to new ways in which art forms are interacting. In an overall sense, I feel that the way we live our lives and treat each other and the environment will be the most important art form of the 21st century.

4

1. *Indian Passion,* acrylic and Indian jewelry

2. *The Journey,* acrylic

3. *Bali Dream,* acrylic

4. *Big Living,* acrylic

ANN WILSON

Since coming together in the 1970s, **Heart** has managed to weather various musical trends. They've produced hit after hit, sharing the rest of the chart with pop, dance, and rap musicians—not a bad record for a group that began playing six nights a week to unpredictable audiences in Seattle lounges. As Nancy says, "Heart is living proof that a band can survive trends and fads. We're proud of our longevity in an era of disposable music."

Nancy Wilson (singer, guitarist, and writer) and her sister Ann (lead singer and writer) are the driving creative force behind Heart. Together they produce music with the power of hard rock and the more subtle properties of classic pop. Among their more well-known tunes are "Crazy on You," "Barracuda," "What About Love," and "Never."

I guess you'd call me more of a cartoonist. The images I draw resemble the inside of my mind.

—Ann Wilson

Desire Walks On, pen and ink

NANCY WILSON

> *Drawing and painting is the pure connection to the love of art.*
>
> *It doesn't matter if you're trained or even good at it. It's especially great therapy for me since no money is involved.*

—Nancy Wilson

Renaissance Man, rapidograph pen

RON WOOD

Ron Wood, the youngest child of a musical and artistic family, was born in England. He and his two brothers, Ted and Art, were influenced by their father, who played with a 24-piece band. The two older boys ended up performing themselves—with the **Temperance Seven** and **Alexis Korner's Blues Inc.** Ron made his debut at the age of nine, playing washboard in a skiffle band.

Wood remained enchanted with music. After high school he went to Ealing Art College. There he joined the **Thunderbirds**, a group that later became the **Birds**. From then on there was no doubt that music would become the major influence in his life. Wood eventually become one of the **Faces**, a group in the seventies that featured Rod Stewart as lead singer. Wood was later invited to be a temporary replacement for the **Rolling Stones** guitarist, **Mick Taylor**, but ended up staying on as a full-time member of that group.

1

Over the course of his twenty-five-year career, Wood has performed with many of his heroes, including **Jerry Lee Lewis**, **Ray Charles**, **Fats Domino**, **Bo Diddley**, **Chuck Berry**, and **Bob Dylan**.

During his time with the Faces and the Stones, Wood never stopped sketching—in dressing rooms or backstage, at home with his family and friends. It was as natural to find him with a pencil in his hand as a guitar. Wood has exhibited his art in Europe, America, and Japan. His work includes oils, woodcuts, lithographs, and etchings.

1. *Billie Holiday & Bessie Smith,* screen print
2. *Beggar's Banquet,* oil on canvas
3. *Keith Richards,* oil on canvas

2

3

" *It's not difficult for me to do self-portraits. It's like drawing any other subject except that it happens to be me.*

You can never say when the inspiration to draw is going to hit you.

I always intermingle my art and music, letting one be conducive to the creation of the other.

At a very early age you either take a shine to something or you don't. For me, drawing was all I wanted to do. That and drumming.

ABOUT THE AUTHOR: DICK GAUTIER

Dick Gautier was drawing cartoons for his Los Angeles high school paper when he was sixteen and doing standup comedy in a nightclub when he was eighteen. After being discharged from the Navy, he opened at San Francisco's "hungry i" nightclub. He was spotted at the Manhattan supper club "The Blue Angel" and signed for the title role in *Bye Bye Birdie* on Broadway for which he received a Tony and Most Promising Actor nomination. In Hollywood he starred in five TV series including "Get Smart" (Hymie, the robot). He has had over 300 guest-starring roles on TV and in motion pictures and has written and illustrated three books on the art of cartooning, caricature, and portraiture. He is co-author, with Jim McMullan of *Actors as Artists*, also published by Journey Editions.

1. *Satch*, acrylic
2. *Scratchboard study*, scratchboard

ABOUT THE AUTHOR: JIM McMULLAN

Noosepaper, newspaper and rope

Jim McMullan attended New York University, Parsons School of Design, and the Univeristy of Kansas. He has studied design and sculpture, and holds a degree in architecture. An actor as well as an artist, McMullan has spent a lifetime appreciating characters and caricature. He has appeared in "MacGyver" and "Doogie Howser, M.D.," among many other television shows, and is probably best known for his portrayal of Senator Dowling on "Dallas." He has appeared in such films as *Downhill Racer*, *Shenandoah*, and the new feature film *Judicial Consent*. He is co-author, with Dick Gautier, of *Actors as Artists,* also published by Journey Editions.

CREDITS

Jon Anderson: photo by Tami E. Freed

Joan Baez: photo by Jack Casey

Paul Barrere: photo by Stephen Stickler

Pat Benatar: photo by Eric Charbonneau

Tony Bennett: photo by Erik Landsberg

Derrick Bostrom: photo by Michael Halsband

David Bowie: photo by Mary Hilliard

Eric Burdon: photo by Judit Andras

Rosanne Cash: photo ©1994 Columbia Records. Used by permission.

Judy Collins: photo by Jim Houghton

Alice Cooper: photo by Ken Ballard ©1987

Miles Davis: photo by Bag One Arts

Mickey Dolenz: photo by Stephen Stickler

Perry Farrell: photo by Alastair Thain

Dan Fogelberg: photo by Henry Diltz; art photographed by Scott Christopher

Lee Freeman: photo by Stephen Stickler

John Frusciante: photo by Stephen Stickler

Jerry Garcia: photo by Vince DiBiase © 1992

Dick Gautier: photo by Ralph Merlino

Peter Himmelman: photo by Stephen Stickler

Cris Kirkwood: Michael Halsband

Curtis Kirkwood: Michael Halsband

Robby Krieger: photo by Stephen Stickler

John Lennon: photo by Iain MacMillan

Peter Lewis: photo by Kirk Candlish

Brian May: photo by Richard Young

John Mayall: John Mayall photograph by Richard McLaurin for Silvertone Records Ltd.
Used by permission. All rights reserved.

Les McCann: photo by Stephen Stickler

Roger McGuinn: photo by Henry Diltz

Jim McMullan: painting of the author by Billy Dee Williams, ©1994
 Billy Dee Williams Artworks, Inc.

Randy Meisner: photo by Stephen Stickler

John Mellencamp: photo by Kurt Markus

Nick Menza: photo by Stephen Stickler

Johnette Napolitano: photo by Stephen Stickler

Graham Nash: photo by Siddons & Associates

Kim O'Donnell: photo by Rosemarie Mattrey

Yoko Ono: photo by Jayne Wexler; art photographed by David Behl

Lee Oskar: photo by Jim Hagoplan

Iggy Pop: photo by Stephen Stickler

Jeff Porcaro: photo by Susan Porcaro

Carly Simon: photo by Bob Gothard

Floyd Sneed: photo by Stephen Stickler

Ringo Starr: photo by Private Music

Donna Summer: photo by Harry Langdon

Dwight Twilley: photo by Robert Knight

Ricky Van Shelton: photo by Jackson Goff

Rick Vito: photo by Stephen Stickler

Roger Waters: photo courtesy of Timothy White

Peter Westheimer: photo by Vladimir Dirljan and Lucille Martin

Ann Wilson: photo by Karen Moskowitz

Nancy Wilson: photo by Karen Moskowitz

OTHER JOURNEY EDITIONS TITLES

WAKE FOR THE ANGELS
by Mary Woronov
isbn 1-885203-00-4

Mary Woronov interweaves the colorful palette of language and the vividness of the painted voice.Woronov's stories and her paintings together create a vision of life so forceful and compelling that it demands our attention. Wake for the Angels *looks at childhood, relationships, love, and loneliness.*

ASYLUM EARTH
by Charles Bragg
isbn 1-885203-07-1

Irreverent and brilliantly funny, Bragg brings us a view of his own special reality— and sheds new light on what we know of our own. Witticisms, satire, and irony abound, and no profession or institution escapes Bragg's sharp eye.

EARTHLY PARADISE
by Hiro Yamagata
isbn 1-885203-04-7

Using the bodies of fully restored, vintage Mercedes-Benz roadsters as the "canvas" for elaborate tropical images, Hiro Yamagata has radically reversed the scale of his work, creating a group of paintings he can literally enter and drive away.

LANGUAGE OF THE HEART
by Anthony James
isbn 1-885203-05-5

The poetry and painting of Anthony James are the language of the heart; he lets us hear his art as well as see it, and allows us to become part of the metamorphosis into understanding and feeling. A deeply compassionate and beautiful book, Language of the Heart *shows us the true spirit that informs an artist's work.*

THE DRAGON'S EYE
by Duncan Regehr
isbn 1-885203-03-9

*In the spectacular paintings presented here, Regehr's clarity of thought about our complex world
is characteristically rendered with jewel-like use of color and many-faceted imagery. The accompanying
text reveals his sensitivity to human experience and to the order of nature.*

THIS FACE YOU GOT
by Jim McMullan
isbn 1-885203-01-2

*Jim McMullan presents portraits of the public personalities of our time by over 144 illustrators
who specialize in fine art, caricature, political cartooning, advertising, and movie posters. Sure to become
the definitive guide to illustrators working in the field today, This Face You Got highlights artists such as
Al Hirschfeld, Charles Bragg, Robert Risko, Milton Glaser, and Bernie Fuchs.*

HOW TO GET HUNG
by Molly Barnes
isbn 1-885203-07-1

*In this accesible, easy-to-read, detailed guide for artists, students, and aspiring art professionals,
Molly Barnes takes the mystique out of "how to get hung." Readers learn how to present
their work and themselves to the professional art world.*

ACTORS AS ARTISTS
by Jim McMullan & Dick Gautier
isbn 1-885203-02-0

Throughout the pages of Actors as Artists, *we see the work of many of our favorite actors,
beautifully reproduced in full color, and hear, in their own words, how their love of art has
developed, and how art asserts itself in their lives.*

HEART OF THE MATTER
by Kristin Nelson Tinker
isbn 1-885203-09-8

Heart of the Matter *draws us into the artist's autobiographical paintings the way one is drawn through the treasures stored away in an attic. Tinker's paintings, executed purely by unique perception and instinct, have received international critical acclaim as being the epitome of the American naïve tradition.*

ART OF THE VINEYARD
by Gary Conway
isbn 1-885203-10-1

Comparable to A Year in Provence, *Conway's* Art of the Vineyard *is a tale about the art of the land, the grapes, and their cultivation. Illustrated throughout with Conway's brilliant, full-color paintings of the vineyard landscape.*

PARADISE FOUND
The Art of Amy Zerner
by Monte Farber & Rose Slivka
isbn 1-885203-11-X

Paradise Found *is about the evolution of the unique artistic style of Amy Zerner, one of the leading collage artists in the world. Zerner uses found objects to make her magic collages explode with images of the beautiful, but usually unseen, worlds and energies that surround and support us all, realms of Paradise that are the origin of beauty.*